IMAGES of America
SOUTH PASADENA'S OSTRICH FARM

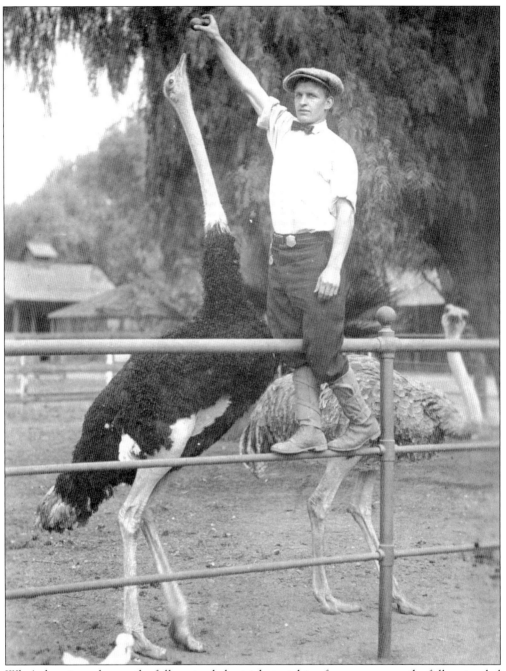

Who's the winner here—the fully extended ostrich stretching for an orange or the fully extended man? If it's a height contest, there's no match; the man wins—but he cheated!

ON THE COVER: In 1927, Franchon and Marco's vaudeville show featuring the Sunkist Beauties performed at the Rialto Theater in South Pasadena. The world-famous Cawston Ostrich Farm in town supplied the ostrich feather plumes for the dance troop's extravaganza *Indian Summer Idea*. (Courtesy Rick Thomas collection.)

IMAGES of America
SOUTH PASADENA'S OSTRICH FARM

Rick Thomas

Copyright © 2007 by Rick Thomas
ISBN 978-0-7385-5578-2

Published by Arcadia Publishing
Charleston SC, Chicago IL, Portsmouth NH, San Francisco CA

Printed in the United States of America

Library of Congress Catalog Card Number: 2007927478

For all general information contact Arcadia Publishing at:
Telephone 843-853-2070
Fax 843-853-0044
E-mail sales@arcadiapublishing.com
For customer service and orders:
Toll-Free 1-888-313-2665

Visit us on the Internet at www.arcadiapublishing.com

To the remarkable women in my life: my grandmother, Lorene, for her vivid memory, love of history, and our wonderful conversations; my mother, Mary, for her creative spirit and unconditional love; my sister, Perri, for her uncompromising intellect and incomparable beauty; my wife, Hitomi, for her dedication to our family and passion for our marriage; my daughters, Lauren and Maia, for making me a better father and a better man each and every day.

Contents

Acknowledgments		6
Introduction		7
1.	The Amazing Ostrich: Oddities of the World's Largest Bird	9
2.	Midnight Run: From Cape Town to Our Town	25
3.	Cawston Ostrich Farm: One of the Strangest Places on Earth	43
4.	Harnessing the Sun: A Solar Power Success	69
5.	High Fashion: Royalty and the New Mail-Order Gentry	77
6.	Feathers of Stage and Screen: That's Entertainment!	97
7.	Local Tourist Attractions: Gardens, Lions, and Railroads	113
8.	Cawston's Today: His Legacy Lives	123

ACKNOWLEDGMENTS

First and foremost I'd like to thank Jerry Roberts at Arcadia Publishing for his unwavering support of this project. It's sad but true: community interest in historic places fades over time until many of them are forgotten entirely. The Cawston Ostrich Farm was the largest employer of South Pasadena residents for over 30 years. And yet, very few people today even know it existed. This book would not have been possible without Jerry's enthusiasm and love of history.

It takes the persistent effort of a few good people helping others to rediscover the wealth of history—like a gold mine—in their own neighborhood (sometimes in their own backyard). Two such leaders of historical education in my hometown of South Pasadena are Glen Duncan and Norma LeValley. Their passion and tireless dedication to historical preservation and community awareness is rare, and we are lucky to have them.

A special thanks to Richard Beebe, Mike Shea, and Steve Fjeldsted at the South Pasadena Public Library for continuing to open up their photograph archive for another community history book. They truly uphold the highest ideals and traditions of a community-based public library system—ease of access and freedom of information.

Finally I wish to thank my daughter, Lauren Thomas, for being the photographer of the present-day historical site images in this book. Her quality photographs and her ability to assist me in historical photograph editing truly enhanced the production value of this project. Lauren was also the editor of the manuscript and helped when I got mentally stuck and had difficulty deciding between areas of history to cover. Lauren knows more about our city's history than all but a handful of residents—and they're the ones who actually lived the history!

INTRODUCTION

It is probably hard to imagine just how popular ostrich feathers were 100 years ago. Today women's fashions come and go so quickly that they resemble more a passing fad with each season. Ostrich feather fashions remained popular in America for nearly 50 years! The ostrich feather symbolized wealth and upper-class refinement much like the way a fine automobile does today. One Cawston catalogue declared: "Ostrich feathers are now as staple as diamonds. They do not fluctuate in popularity like furs, and are constantly used."

Ostrich feathers were dyed in a variety of colors, ranging from black, white, light blue, and pink. They were handcrafted into an array of garments and accessories such as boas, hats, fans, and muffs. Imagine the scene in the late 1800s. The Victorian period dictated a flowing and less ambiguous adornment. Ostrich feathers piled atop a broad-rimmed hat had an airy-floating grace that seemed to accent perfectly the more restrained cotton dress with a corset pulled tight beneath. Prices remained high for imported ostrich feathers from South Africa, the principal supplier of ostrich feathers for the world's fashion community at that time. Edwin Cawston, English adventurer and world traveler, quickly realized that there was big money to be made in ostrich farming in America. He was convinced that Southern California, with its year-round mild climate, was the perfect place to launch his new business enterprise.

The Cawston Ostrich Farm was world famous in its time and remained in business for over 30 years. All the structures have been demolished over time, and most people today don't even know the farm existed.

These places of our past are not always preserved. But our memories of them and the great showmen who built them can be. By telling and retelling their stories, others may learn that success sometimes takes more than a dream. It takes a whole lot of hard work and passion, and it often takes one more very important ingredient: a big leap of faith. We may follow their inspiration of 100 years ago and strike out on our own, like Thaddeus Lowe, who once built a great railway into the clouds, or like Edwin Cawston, who built a business empire from nothing more than ostrich feathers.

ABOUT THE OSTRICH FARM PHOTOGRAPHS
This book was created primarily using my collection of items related to the history of the Cawston Ostrich Farm in South Pasadena, California. The South Pasadena Public Library provided their historical archive photographs for the book as well, allowing me to show behind-the-scenes views rarely seen in history books. They were acquired from the Cawston Ostrich Farm itself years after its doors were closed to the public. This book was made possible by merging these two great collections into one comprehensive display of rare and unusual images never before published. Courtesy lines were provided for all images that weren't from my own collection.

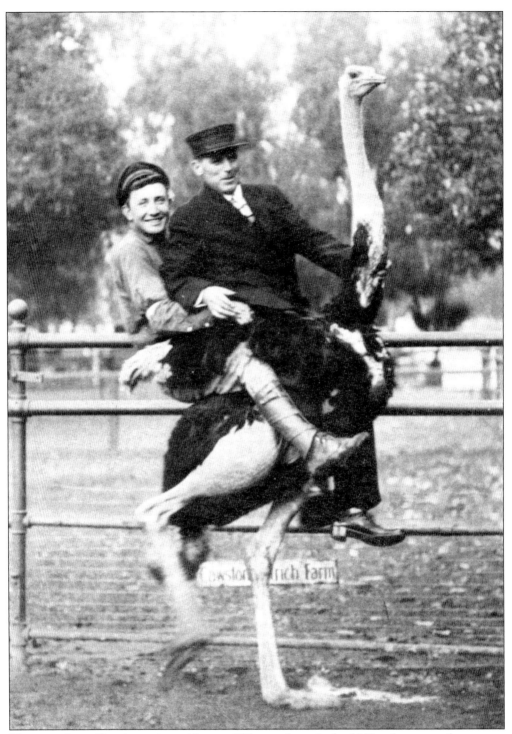
This ostrich is off and running with over 300 pounds on its back! For the more adventurous guests of the Cawston Ostrich Farm, one could take the ride of a lifetime.

One

The Amazing Ostrich
Oddities of the World's Largest Bird

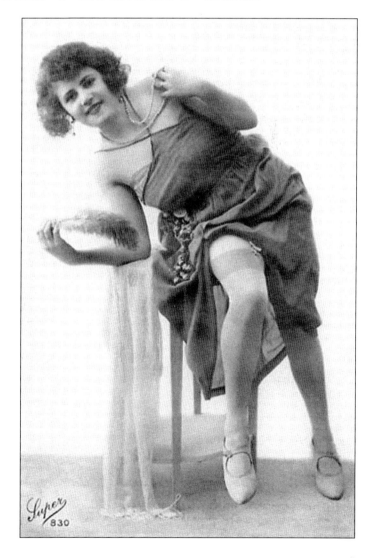

This honey is displaying more than her ostrich feather. Before Edwin Cawston brought ostrich farming to America, there was little known about the world's largest bird. Surprisingly ostriches were very popular in product advertising. Its feathers were used by royalty and showgirls alike.

The Kick of the Ostrich
KILLS

BUT THE DEATH IS NO MORE CERTAIN AND FAR LESS PAINFUL THAN THE LINGERING—LIVING DEATH CAUSED BY CONSTIPATION

Save Your Life

BY TAKING

Ma-Le-Na Stomach=Liver Pills

Trade-Mark

THE BEST VEGETABLE TONIC-LAXATIVE AND BLOOD PURIFIER

They Cure Constipation

GUARANTEED TO CURE OR MONEY REFUNDED

Malena Company, Manufacturers, Warriorsmark, Pa., U.S.A.

Advertisers often used certain characteristics of the ostrich to draw attention to their products. This one speaks for itself.

Ostriches have voracious appetites. They'll eat anything small that gets near them. At the Cawston Ostrich Farm, guests were warned to put away their diamond jewelry because ostriches are particularly fond of sparkling objects. And apparently they prefer Pepsi to Coca-Cola.

The clothing outlet Cooley's created a fancy character named the Dude Masher to show that low-priced clothing could also be stylish.

Real Comfort.

No-Saw-Edge
ON COLLARS AND CUFFS

We have patented the only machine which removes the rough edges on collars and cuffs. We also produce the least destructive and most artistic polish to linen.

We have facilities for doing family washings separately.

Every department of our service is modern, reasonable and safe.

Empire Steam Laundry

Telephone Main 635 149 South Main St., Los Angeles

Simply the presence of an ostrich placed in small advertisements could draw attention to the product or service offered.

Amazingly, Ivory Soap can also be used to clean ostrich feather boas.

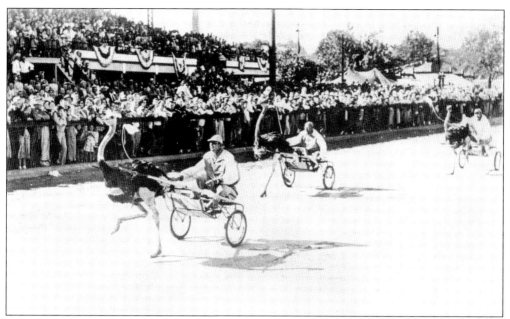

This 1923 ostrich race took place in Anaheim, California, in front of huge crowds. Public spectacles like this were popular in the early 20th century. Another famous race took place at Chutes Park in downtown Los Angeles between a dirigible and an automobile. The automobile broke down early in the race and nearly beat the airship in a mad dash to the Raymond hotel.

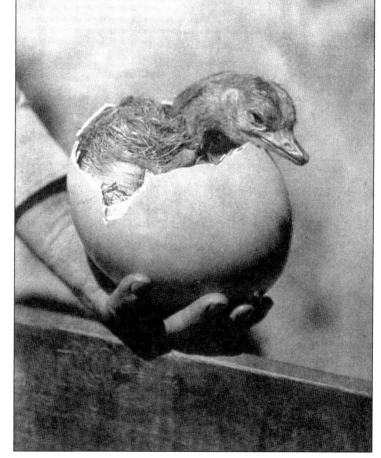

The newly hatched baby ostrich chick is a giant among its bird-family peers. (Courtesy South Pasadena Public Library.)

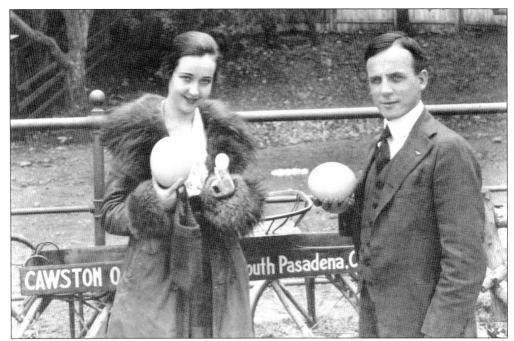

Actress Helen Jerome Eddy and Herbert Vatcher Jr. compare an ostrich egg to a chicken egg at the Cawston Ostrich Farm in South Pasadena, California. (Courtesy South Pasadena Public Library.)

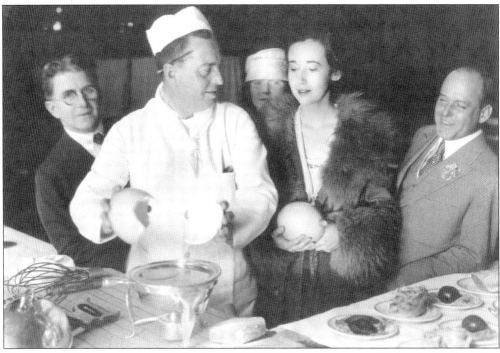

During a publicity stunt, actress Helen Jerome Eddy looks on as a master chef at the Ambassador Hotel in Los Angeles cracks open an ostrich egg from the Cawston Ostrich Farm. (Courtesy South Pasadena Public Library.)

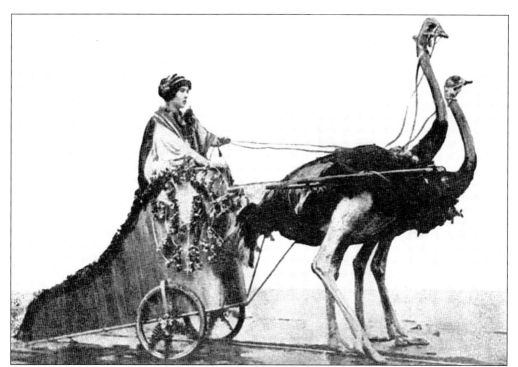

Chariot races were popular during the early years of Pasadena's Tournament of Roses festivities. One year two ostriches were used instead of a horse. The pair's awkward appearance and refusal to go in a straight line caused the crowd to roar with laughter.

Watching ostriches swallow whole oranges was so popular at the Cawston Ostrich Farm that attendants gave demonstrations, which drew huge crowds.

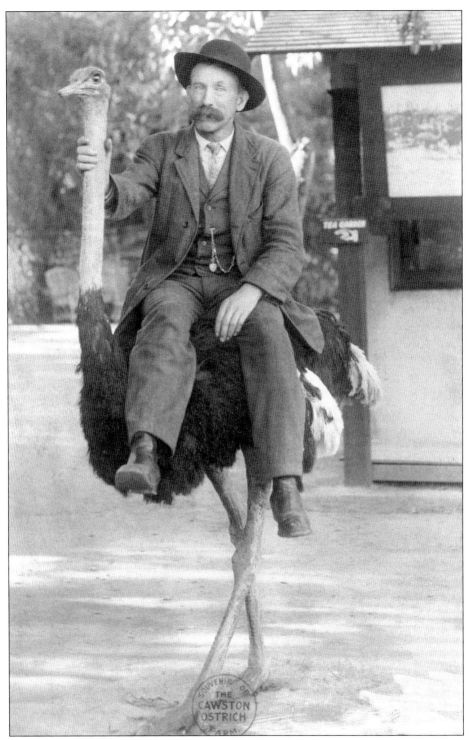

Taking a souvenir photograph with an ostrich was a must at the ostrich farm. Imagine receiving this photograph as a postcard from a friend or family member visiting the West Coast on vacation. They would probably declare: so that's what they do out there in California!

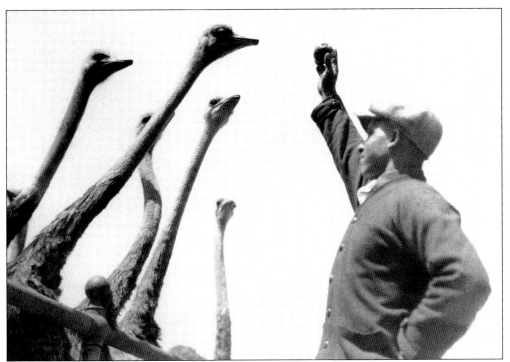

This ostrich feeding resembles a snake pit—like cobras waiting to strike.

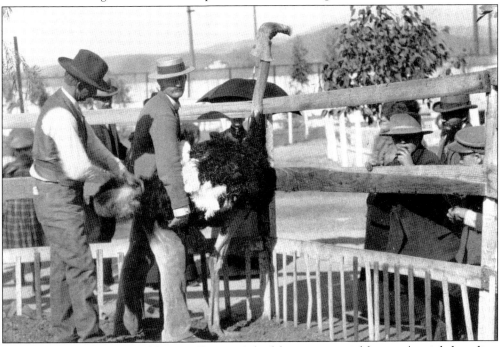

On a serious note, pictured here is Cawston's highly controversial human/ostrich breeding experiments . . . NOT! This attendant of Cawston's Ostrich Farm is actually holding the male ostrich still while its choice white feathers are being removed using clippers. (Courtesy California Historical Society.)

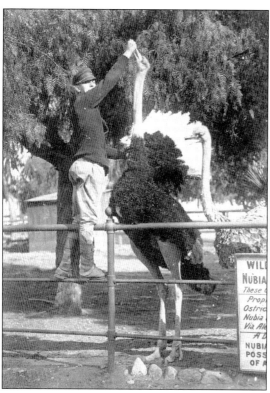

This fully extended ostrich appears to be almost as high as the pepper trees in the background. Note the plumage of the male ostrich as compared to the female ostrich on the right. His legs are pretty sexy as well.

Ostriches were given names of famous cartoon characters, American presidents, and popular actors at the Cawston Ostrich Farm. These tourists pose for a photograph with one of Cawston's more cantankerous ostriches. Hanging on the ostrich pen fence is a sign that reads "Fighting Bob Evans."

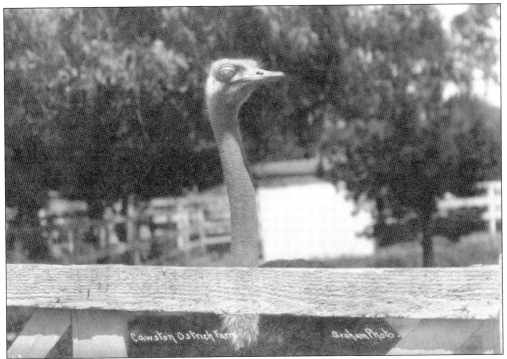

Here's an interesting fact: an ostrich's brain is no bigger than the size of its eyeball. (Courtesy South Pasadena Public Library.)

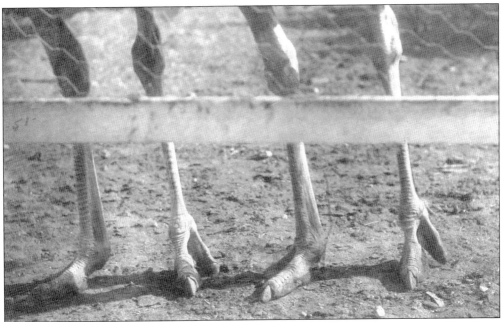

Ostrich are strong and potentially dangerous. And yes, the kick of an ostrich is powerful and can kill under certain circumstances. Its feet, on the other hand, only a mother could love. (Courtesy South Pasadena Public Library.)

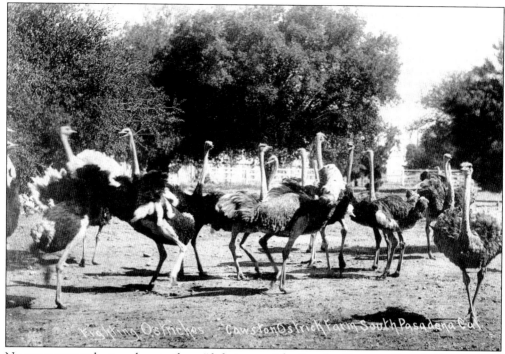
No one wants to be too close to these "fighting ostriches" at the Cawston Ostrich Farm . . .

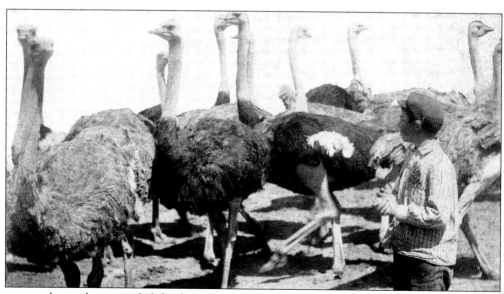
. . . so what is this young lad thinking?!

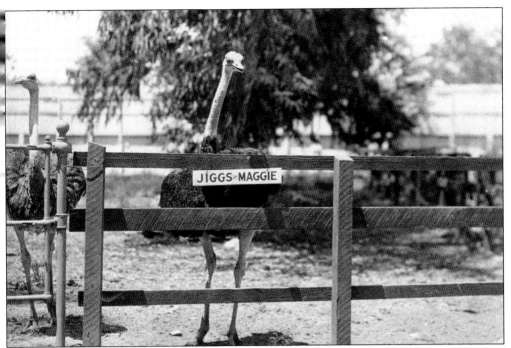

So there really is a Jiggs and Maggie . . . and they're ostriches living at the Cawston Ostrich Farm in South Pasadena, California. Actually *Bringing up Father* was a popular comic strip created in 1913 by George McManus and featured as its two main characters Maggie and Jiggs. The comic strip continued under two other artists and lasted 87 years in publication.

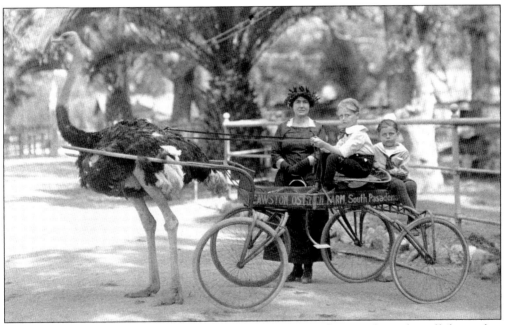

Tourists generally felt more comfortable posing for souvenir photographs with stuffed ostriches for obvious safety reasons. This youngster is ready to take a joyride around Cawston's farm behind the reins of a live ostrich. Remember what size an ostrich's brain is?

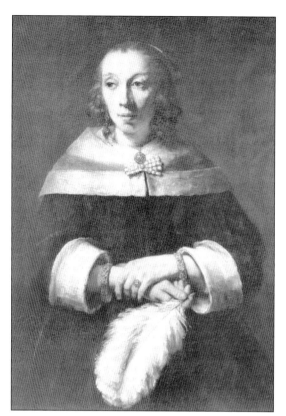

A single ostrich feather is seen in paintings and drawings throughout human history, from Rembrandt's famous painting of a woman with an ostrich feather, to Egyptian art illustrating a single ostrich feather headdress. (Courtesy National Gallery of Art.)

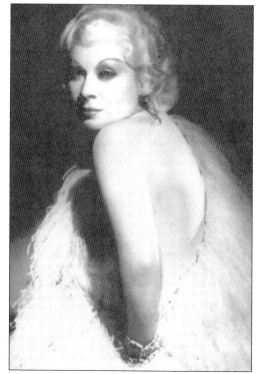

In modern human culture, ostrich feathers were often used to accent a woman's sex appeal and high degree of confidence, as was the case with popular movie star Mae West.

In this whimsical vintage postcard, two men try to get under the woman's broad-rimmed ostrich-feather hat to win her affections. The reverse side of the postcard reads that one man failed because he didn't remove his hat like a gentleman.

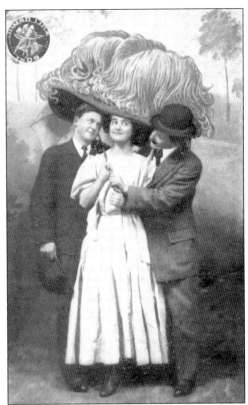

This late-19th-century book proposes the end of all war and the elimination of hunger by establishing farming cooperatives throughout the world. The book gives an example of a successful ostrich farm cooperative in South Africa.

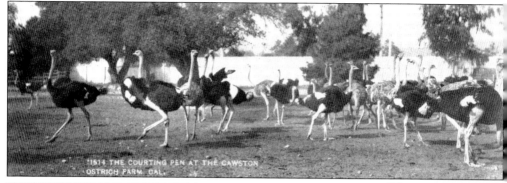

The courting pen at the Cawston Ostrich Farm was a very strange dance between ostriches. Here they displayed their bizarre mating rituals much to the delight of the guests.

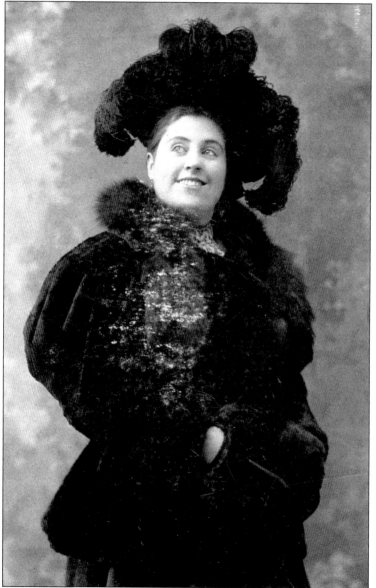

The author's family had a very strange aunt named Edna who also liked to engage in strange dances of her own. Don't ask.

Two

Midnight Run
From Cape Town to our Town

Edwin Cawston was a tireless world traveler and business opportunist, always in search of stressed businesses to invest in that offered quick growth potential. He had a reputation for being a shrewd businessman with a flair for showmanship. He used these skills to court investors and get struggling businesses off to a good start. In July 1886, Cawston traveled to South Africa on a visit that would later be known as his greatest adventure of all.

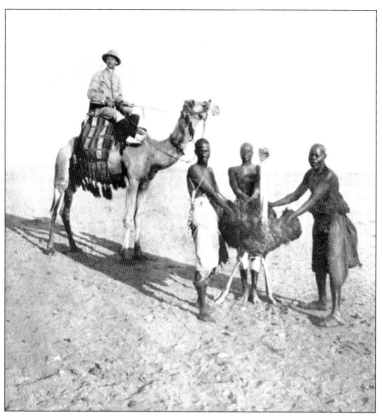

Edwin Cawston frequently gave spellbinding speeches to launch his new enterprises, but shortly thereafter, he would cut and run, oftentimes leaving to visit other countries. Cawston himself attributed this behavior to his sense of adventure. On one such excursion, he traveled to South Africa to investigate opportunities in the ostrich-feather industry for possible export to America. Cawston witnessed every facet of the business firsthand, including capturing ostriches in the wild.

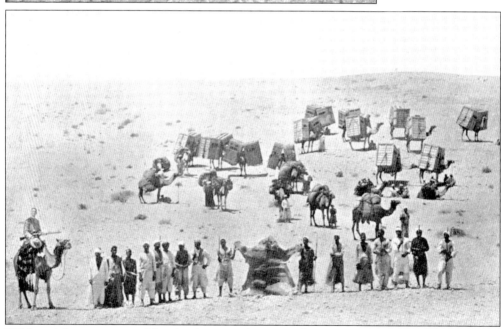

Wild ostriches were carried by the dozens in large wooden crates on camelback during their perilous journey to civilization. All phases of the industry, such as acquiring ostriches, their care, and feather production, were controlled and supervised by English business interests.

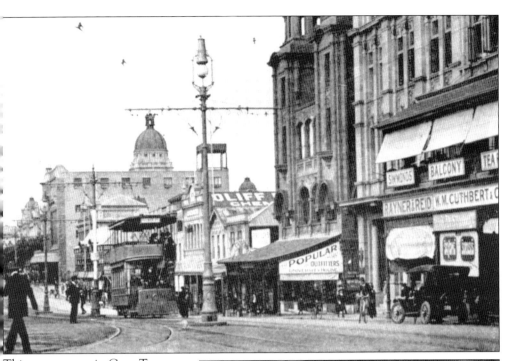

This street scene in Cape Town, South Africa, was taken during the early part of the 20th century. It was the location of Edwin Cawston's greatest personal triumph and became one of America's most popular adventure stories of its time.

This storefront in Cape Town, South Africa, offered tourists bargain prices because of the close proximity of the surrounding ostrich farms. The Cape Town region was the principle supplier of ostrich feathers to the world's highly profitable fashion industry. Ostrich farming in America was not possible on a large scale because of the insufficient number of ostriches required for breeding.

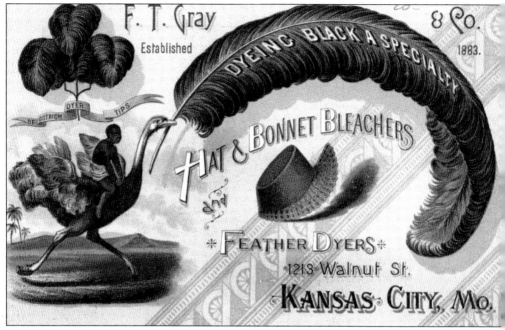

The above advertisement card from 1883 shows an exotic South African scene used to promote the nature of its trade to the Kansas City gentry. Edwin Cawston was convinced there was big money to be made in exporting ostriches to America for farming. To make this business venture a reality, he would need a large flock of ostriches to take back with him to California.

During Edwin Cawston's stay in South Africa, the Cape Colony government caught wind of his business plans in California and hastily passed a law requiring a $500 duty per ostrich and $125 per egg (a huge sum in 1886) to export this magnificent bird to America. In a bold move, Cawston made a midnight run, leaving South Africa with over 50 male and female ostriches on the eve the protectionist law went into effect.

Edwin Cawston first purchased land in the area of present-day Norwalk, California. His early venture here was featured in *Harper's* national newspaper. The article gave the brief history of ostrich farming in America with high praise for its early pioneers and probability for success given American women's appetite for ostrich-feather fashion.

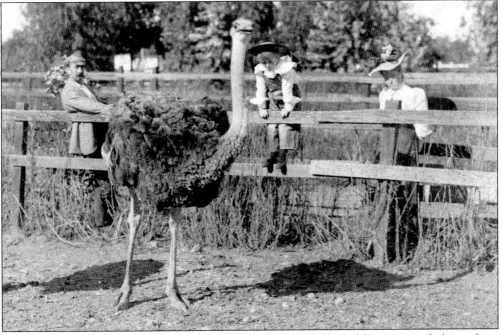

Edwin Cawston is pictured here with his family at his Norwalk, California, ostrich farm where he spent nearly 10 years building up his business. Now that Cawston was ready to take the next step in his mission to become the principle supplier of ostrich feathers in America, he needed a higher profile location in the region to produce and set up retail operations.

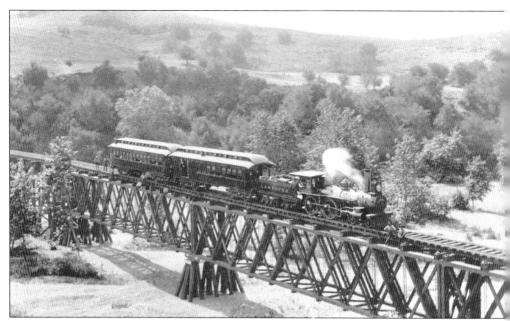

In 1885, this early steamer crossed the Arroyo Seco at the future location of the Cawston Ostrich Farm in South Pasadena. Edwin Cawston knew his prospects all depended on the region's transportation system. The first railroad ventures were established at about the same time Cawston opened his farm in Norwalk. The trains brought much needed building supplies and labor to the region. Property values soared as investors poured into Pasadena, making it a prime destination for agriculture interests and tourism. (Courtesy archives at the Pasadena Museum of History.)

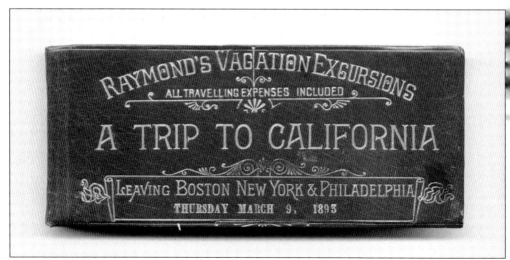

Vacation excursions to California were popular during the 1800s. Walter Raymond was the first to exploit the region's mild winters and paradise-like agriculture resources through his Boston-based travel agency.

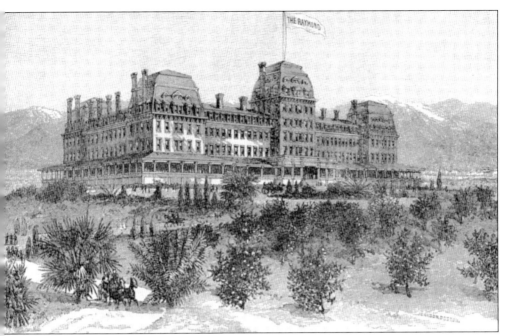

Walter Raymond proposed building the area's first resort hotel on a hilltop in South Pasadena. The project required a huge investment, and like Edwin Cawston, Raymond was determined to bring his large-scale business venture to this part of Southern California.

Edwin Cawston's plan to break the Cape Town monopoly and become the principle supplier of ostrich feathers in America was unknowingly tied to this man: Emmons Raymond, Walter Raymond's father. While grading the hilltop for the hotel, the discovery of granite required costly blasting operations. With over 250 workers sitting idle, the fate of the project was in question. When Emmons Raymond visited the construction site during a rain storm, it seemed to punctuate the feeling of doom for the Raymond hotel project. (Courtesy archives at the Pasadena Museum of History.)

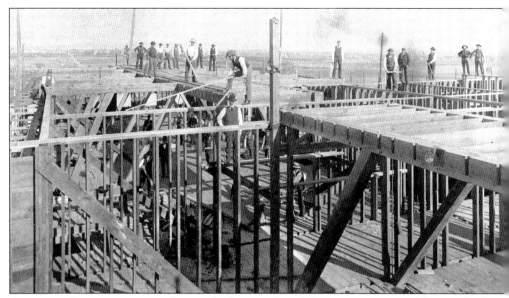

At sunrise the next morning, the rain had stopped, and Emmons was greeted by breathtaking views of the Sierra Madres (known today as the San Gabriel Mountains) and the surrounding grassy hillsides, young orchards, and poppy fields. Emmons decided to give his son the money he needed to complete the hotel. The entire hotel was made of wood, and no structure in Pasadena's history before or since required more lumber to build. Over one million bricks were manufactured on site for the foundation. (Courtesy archives at the Pasadena Museum of History.)

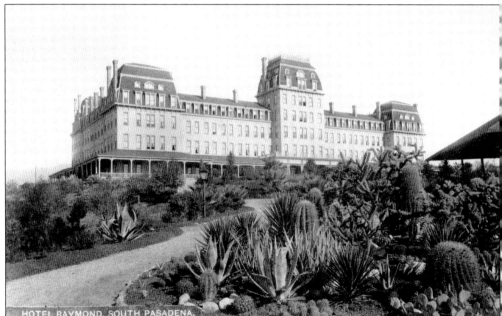

This spectacular 200-room resort hotel, called the Royal Raymond, dominated the landscape for miles in all directions. A grand dedication ball was held at the hotel on November 17, 1886. Edwin Cawston was attracted to South Pasadena because of its proximity to this major resort hotel, knowing it would bring hundreds of wealthy East Coast visitors to the area and make his new enterprise world famous.

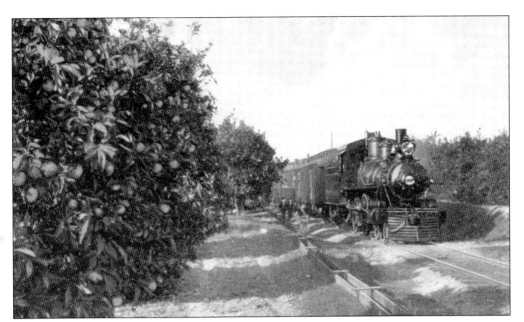

Edwin Cawston was also attracted to the area for another reason: the orange fields. Cawston discovered the oranges, peel and all, were an excellent food source for ostriches. They also provided amusement. When the ostriches swallowed several oranges back to back, large round lumps moved slowly down their skinny hose-like necks.

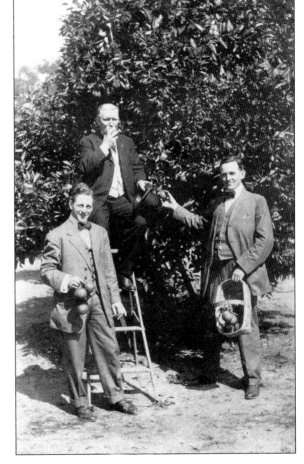

The orange groves were also a favorite for the tourists, who marveled at being able to pluck oranges from trees in the middle of winter. While staying at the Royal Raymond during the entire winter season, they would send photographs back home to their friends who were buried in snow.

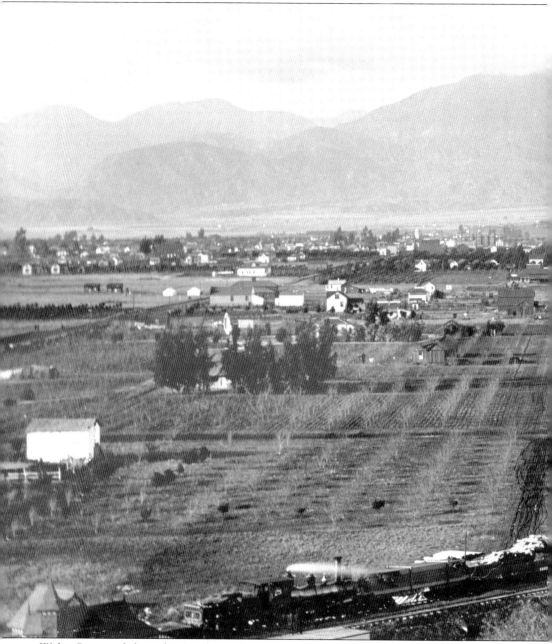

Walter Raymond chose this South Pasadena hilltop to take full advantage of the picturesque view of the mountains and surrounding vineyards, fruit orchards, and pastoral lands. The Boston-based travel agency, Raymond and Whitcomb, and local area boosters hyped this part of the San Gabriel Valley as a "paradise on Earth," and when visitors first arrived at their winter destination, they were

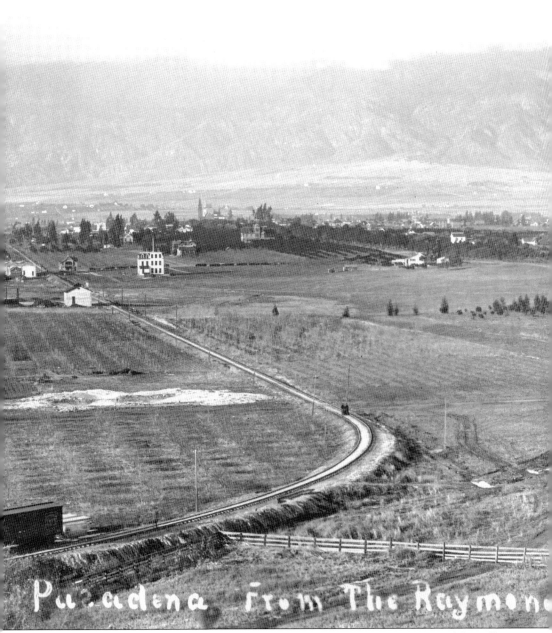

Pasadena from The Raymond

not disappointed. The mountains provided a scenic backdrop to almost every view of the valley. Pasadena, seen in the distance, was a relatively small city in the late 1800s. The wealthy guests from the Royal Raymond hotel began to build their winter mansions in the area. Pasadena grew rapidly, becoming a major influence in the region's future transportation and energy interests.

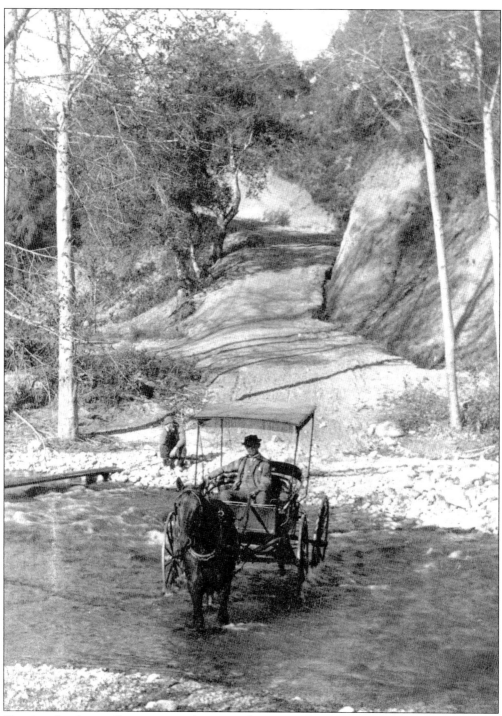

Crossing the Arroyo Seco was treacherous and even more so immediately after a storm. This crossing was made possible by a dirt road from Garvanza on the opposite bank of the Arroyo from the future site of the Cawston Ostrich Farm in South Pasadena. (Courtesy archives at the Pasadena Museum of History.)

The area was still mostly pastoral land in 1896 when Edwin Cawston decided to build his ostrich farm. This scene was located on the bank of the Arroyo Seco adjacent to the future site of Cawston's South Pasadena farm. (Courtesy archives at the Pasadena Museum of History.)

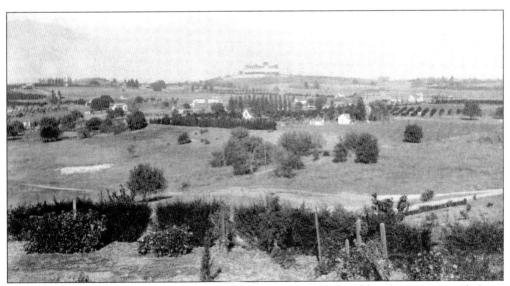

Cawston purchased land near the bank of the Arroyo Seco to build his showcase ostrich farm. Pictured here is the village-sized city of South Pasadena less than a mile from the Cawston Ostrich Farm site. With nearby Pasadena winter tourism at an all-time high, Cawston's goal was to attract large numbers of visitors to his farm and gain national attention in the process.

This photograph was taken on Easter Sunday in 1895 by A. C. Vromans on Columbia Street in South Pasadena, which borders Pasadena. In the distance, smoke can be seen engulfing the Royal Raymond hotel. (Courtesy archives at the Pasadena Museum of History.)

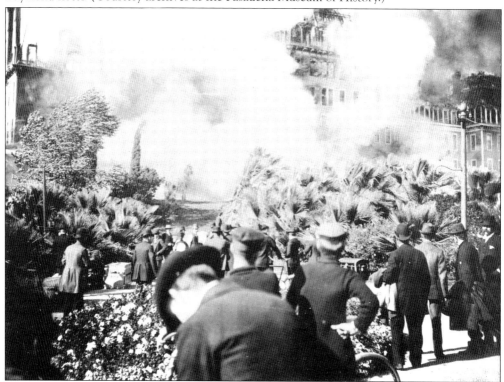

A closer view shows guests standing with their belongings gazing at the enormous fire. Pasadena's new fire department was no match for the firestorm, which is considered the greatest single structure fire in its history. (Courtesy California Historical Society.)

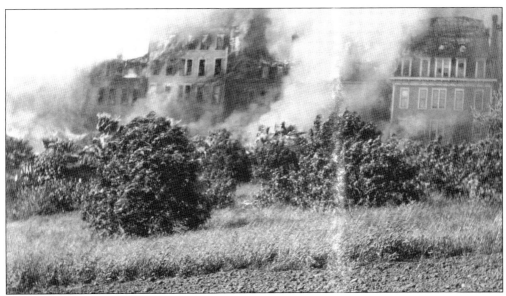

The devastation was total; only a couple of chimneys were left standing. Ironically the spark that ignited the Royal Raymond hotel was a glowing ember from one of the two dozen chimneys.

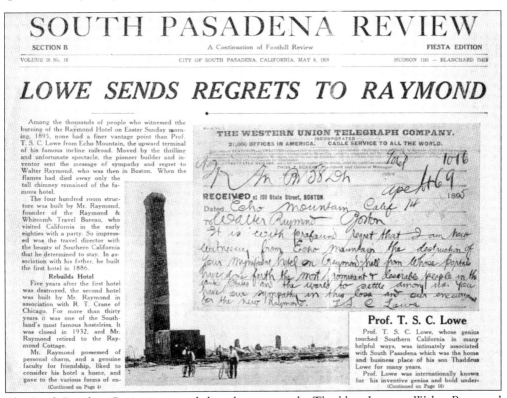

The *South Pasadena Review* reprinted the telegram sent by Thaddeus Lowe to Walter Raymond from his vantage point on Echo Mountain expressing his "profound regret" at witnessing the burning of Raymond's magnificent hotel. Six years later, Raymond would send his regret to Lowe after witnessing the burning of his Echo Mountain house.

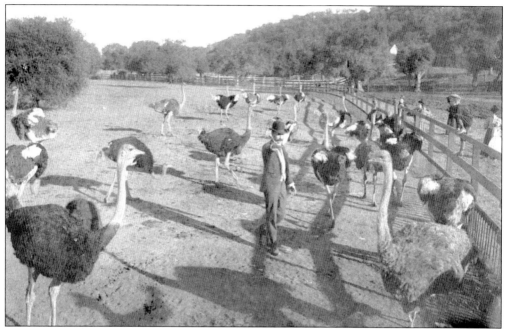

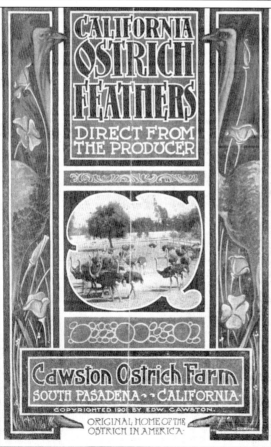

The loss of the Royal Raymond hotel was a major blow to Edwin Cawston. Besides the immediate end of tourists coming to stay at the grand hotel, he was a friend of the Raymonds. Their business interests and prospects for success and failure were inextricably tied to each other. In 1896, Cawston opened his South Pasadena ostrich farm more determined than ever to make it a success.

This 1901 Cawston brochure features on its cover, "California ostrich feathers direct from the producer." Edwin Cawston's business strategy was straightforward and simple: sell high quality ostrich feather products direct to consumers at wholesale prices.

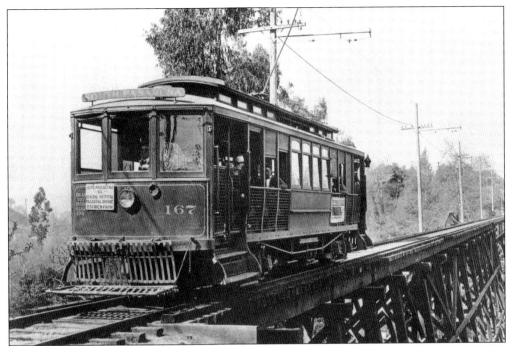
This South Pasadena–bound electric car traveled from downtown Los Angeles and made regular stops at the Cawston Ostrich Farm. Important to the success of the ostrich farm was its location. The farm was strategically situated to take advantage of the many changes in transportation during its years of operation from 1896 to 1934. (Courtesy archives at the Pasadena Museum of History.)

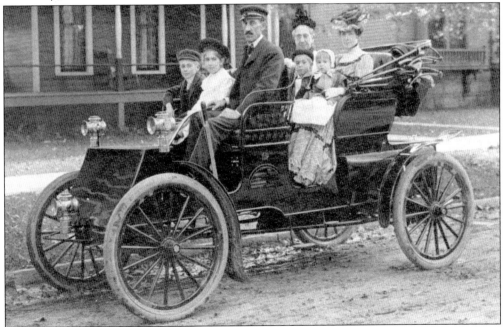
This early automobile looks more like a motorized buggy. Note the steering arm in the driver's lap and the nearby hand brake.

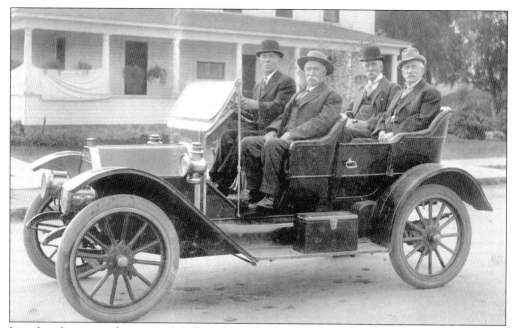

In only a few years, the automobile had changed. Now there was a conventional steering wheel and foot brake, as is present in today's automobiles. These newer model vehicles also came with larger engines that produced considerably more horsepower. Larger fenders, tires, and a windshield were but a few of the improved features.

In 1911, Edwin Cawston donated a large sum of money to the City of South Pasadena to help pay for the completion of the York Bridge that crossed the Arroyo. Of course, the gesture benefited his farm the most by bringing even more traffic directly to his doorstep. Upon completion of the bridge, a new retail store was built at the farm's entrance facing Pasadena Avenue to take advantage of the increased flow of tourists arriving from Los Angeles by the wildly popular automobile.

Three
Cawston Ostrich Farm
One of the Strangest Places on Earth

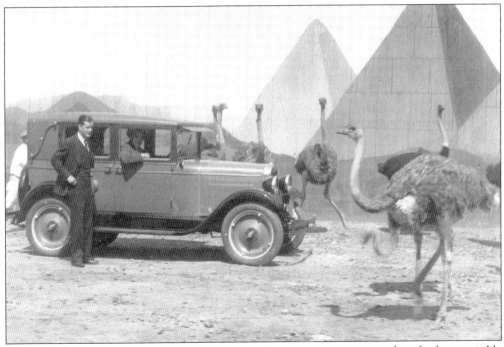

This scene looks like it could be in Africa. Upon closer examination, wooden planks are visible in the pyramids, which are actually painted murals. Also note the partially hidden man on the far left. He is chasing ostriches from behind the car, which explains the frantic ostrich heading directly at the viewer. The Cawston Ostrich Farm was frequently used for publicity shots like this one by the movie industry. (Courtesy South Pasadena Public Library.)

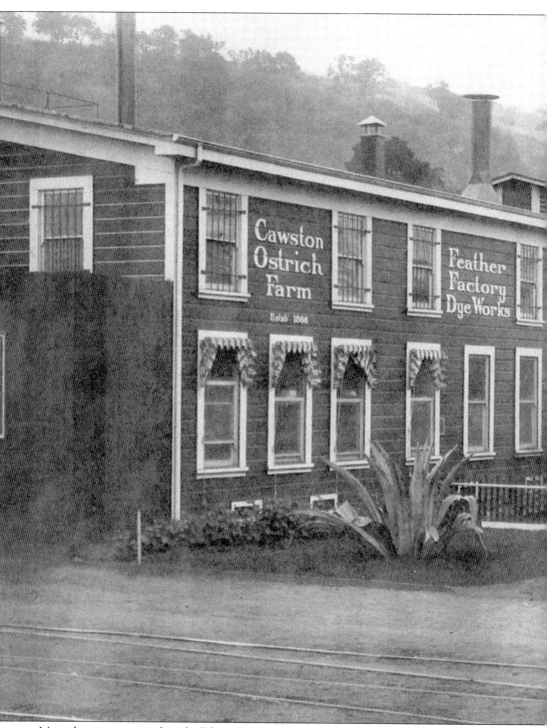

More than one person thought Edwin Cawston was crazy for traveling halfway around the world to acquire ostriches and start a farm on the banks of the Arroyo Seco just after the region's major source of tourism, the Royal Raymond hotel, burned to the ground. But soon after Cawston opened his ostrich farm to the public in 1896, he proved his critics wrong. The New York press

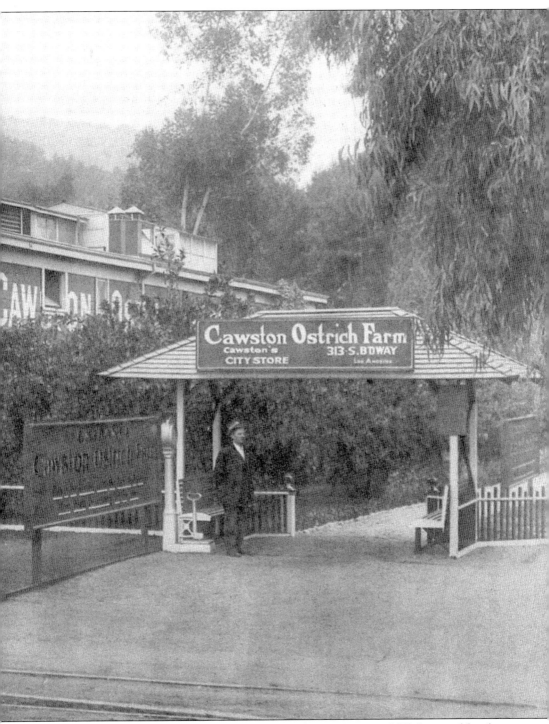

described his ostrich farm as "one of the strangest sights in America." With press like that, Cawston's risky venture was about to pay off. In no time at all, the Cawston Ostrich Farm was a huge success and was regarded as one of California's most popular tourist attractions. (Courtesy South Pasadena Public Library.)

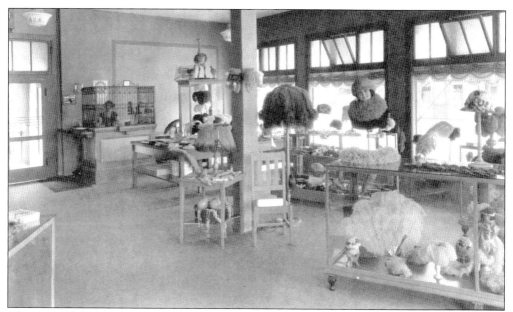

This view of the interior of the Cawston Ostrich Farm store shows the variety of items for sale, including an ostrich quill pen and lamp shades. Round-trip excursion tickets cost 25¢ and included free admission to the farm. Tickets could be purchased at the Pacific Electric Railway ticket office or at Cawston's Los Angeles store at 313 South Broadway. (Courtesy South Pasadena Public Library.)

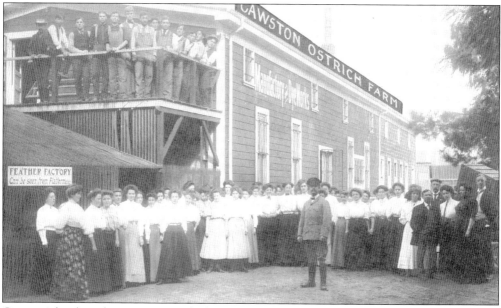

Cawston's loyal employees pose outside the manufactory and dye works building in 1910. Ostriches were rarely seen in America before the beginning of the 20th century. Edwin Cawston's farm was not a typical farm-like environment or a traditional zoo setting, but akin to a modern-day amusement park that rivaled the top Southern California attractions of that time—Santa Catalina's Avalon Bay, Busch Gardens, Mount Lowe Railway, Venice of America canals, and Gay's Lion Farm in El Monte. (Courtesy South Pasadena Public Library.)

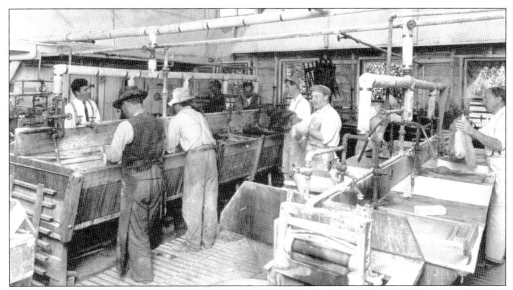

Visitors to the Cawston Ostrich Farm were also treated to walking tours of the entire facility, where all phases of the ostrich feather production were explained and viewed. One promotional brochure read: "Come to the farm prepared to spend several hours in the beautiful semi-tropical park of flowers, palms, trees, etc.; enjoy the comfort of the rustic seats, the pretty lawns and the shaded nooks; take afternoon tea at the Japanese Tea Garden on the farm. See the aviary of rare birds, the Ostrich incubators and young chicks of all ages, how ostrich feathers are dyed, curled and handled." (Courtesy South Pasadena Public Library.)

A Cawston employee walks from the fireproof storage room. Another employee in the background hangs large white plumes to dry on long, braided, steel cables that stretched across the yard resembling a clothesline. (Courtesy South Pasadena Public Library.)

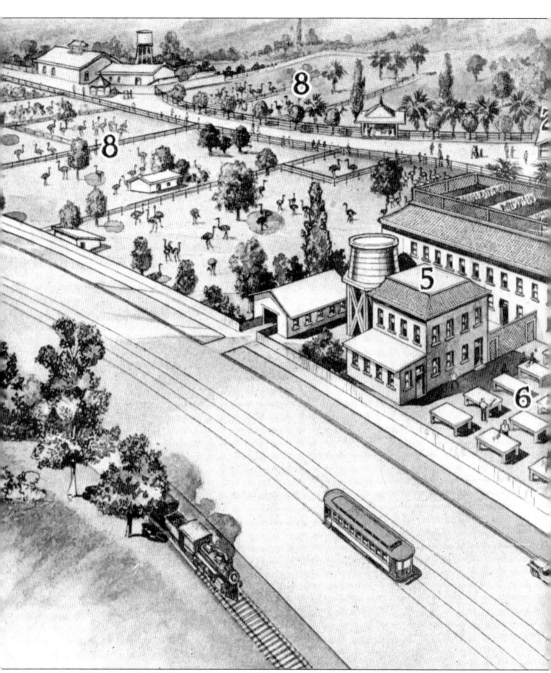

Pictured here in this bird's-eye view is the Cawston Ostrich Farm. Along with descriptions taken from a Cawston brochure dated 1914 are the following buildings: Building No. 1 is the Administration Building, containing the general offices, mail order department, and feather salesroom. Next is the Incubator House (No. 2). "Here the huge eggs are placed in specially built incubators and in 40 days the baby ostrich is hatched." Building No. 3 is the Main Factory Building. "In this large, airy building Cawston's corps of expert workers turn out the world famous Cawston Ostrich Feathers. Here also is located the repair department." Next is the Fireproof Storehouse (No. 4). "In this concrete building is stored the raw stock, the feathers in the seasoning

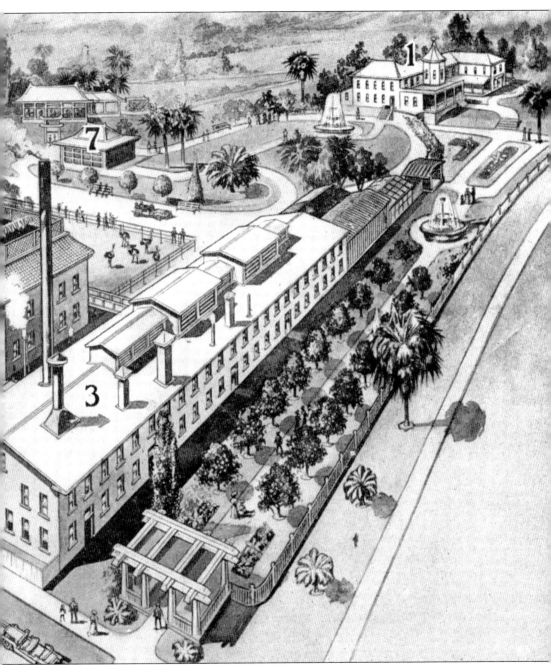

process, and the manufactured goods. On the roof the feathers are dried and cured in California sunshine." In the Dye House (No. 5), "the feathers are dyed by the exclusive Cawston processes." "On these glass-top tables (No. 6), the feathers are cleaned and bleached. In the semitropical climate of California this work can be done out-of-doors the year around." In building No. 7 and building No. 8 are the Aviary of Rare Birds and the Ostrich Pens. "This photograph shows but a small portion of the twelve acres of these pens at this farm. The breeding farm at San Jacinto, California, occupies nearly four hundred acres."

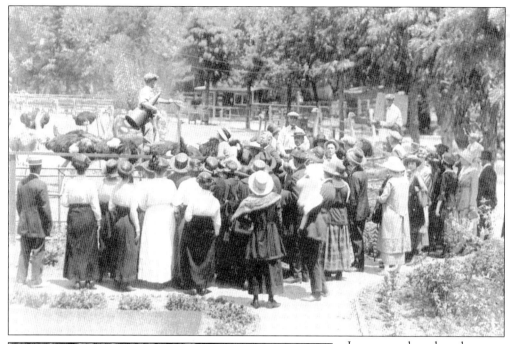

Large crowds gathered to witness the attendants tossing whole oranges to the ostriches. They relished the odd sight of several baseball-sized lumps moving slowly down the ostrich's slender snake-like necks. Another entertaining feature of the farm was watching an attendant ride an ostrich bareback. One Cawston brochure described it as "a most difficult feat and is a rare sight." (Courtesy South Pasadena Public Library.)

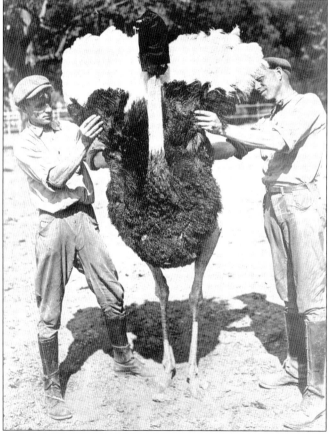

This wire-press photograph shows attendants at the Cawston Ostrich Farm inspecting the grade-A plumes of a prized adult male ostrich.

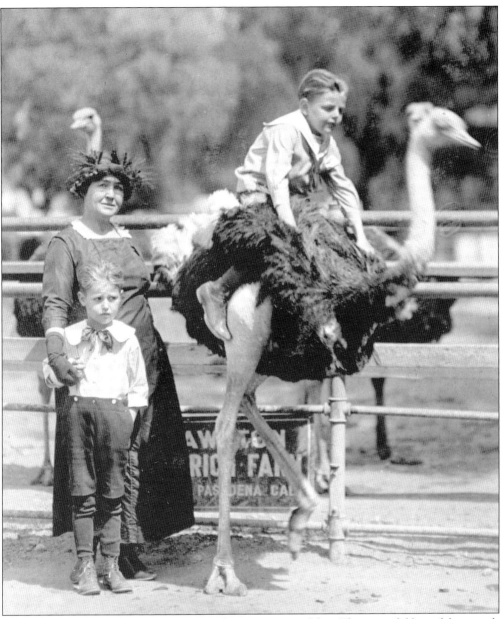

The little boy with his mother looks worried. His is a rational fear. The powerful legs of the ostrich are taller than he is. His brother is pitched forward trying to stay on top of his restless mount. Why do some parents put their kids through this? Because it makes for a great family vacation photograph, of course.

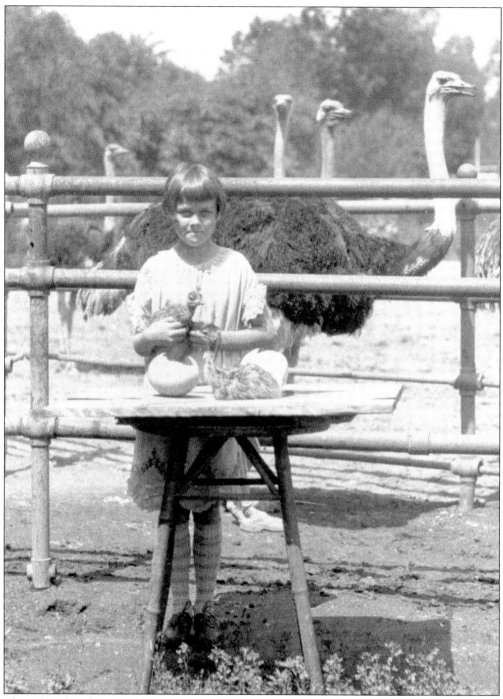
The girl in this photograph proudly poses holding a newly hatched ostrich while an apprehensive mother ostrich moves nervously behind her.

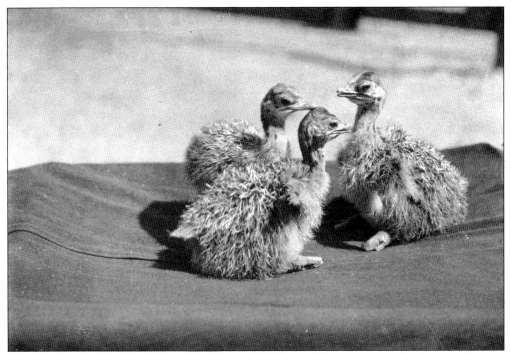

Newly hatched ostrich chicks only appear small by their relative size to each other.

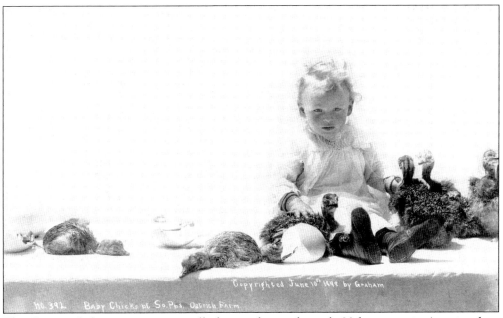

This Cawston baby was more nationally famous during the early 20th century in America than the Gerber baby, who appeared later on all Gerber Baby Food products starting in 1927 (becoming its trademark in 1931). This photograph of the Cawston baby sitting with newly hatched baby ostriches was duplicated over a million times on postcards and a variety of souvenirs collectibles. Here again note the relative size of the baby ostrich chicks to a human baby. They are really big, aren't they?

A rustic path and benches connected the different areas of the farm-like entertainment venues in the amusement park. Trees covered in ivy acted like a canopy offering visitors a shady path out of the direct sun.

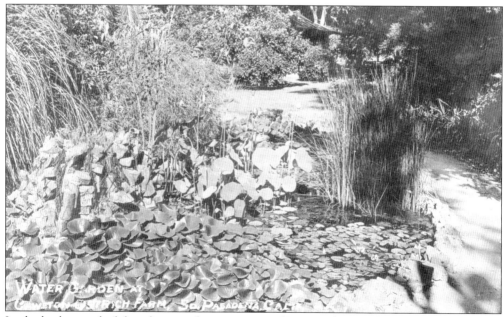

In the background of this photograph is an aviary of "rare and exotic birds," such as peacocks and parrots. Today these birds are considered common in the area, even becoming a nuisance for some local residents.

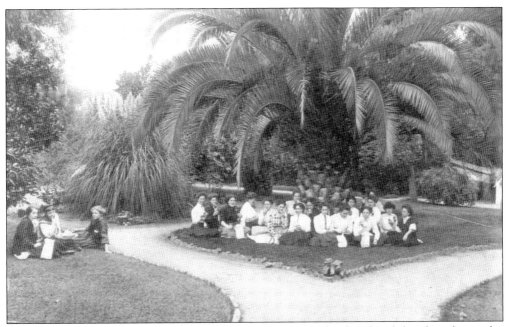

The women who worked in the packaging and mail rooms take their lunch break under a palm on the grounds. (Courtesy South Pasadena Public Library.)

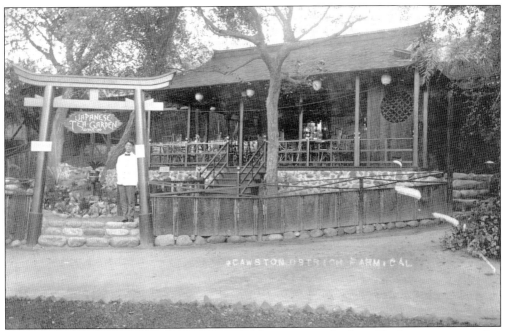

Cawston's Japanese Tea Garden was a favorite for the tourists at the farm. Tea houses were popular, much the way coffee houses, juice bars, and frozen yogurt establishments are today.

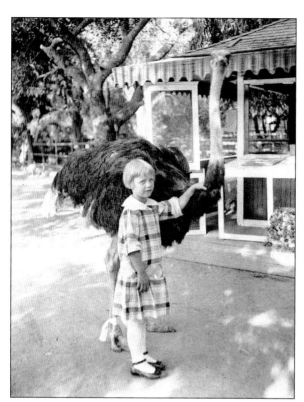

Near the rare bird aviary, Mary Armour enjoys a leisurely stroll with an ostrich.

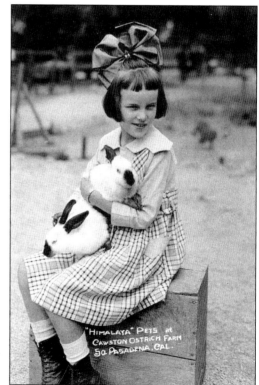

Edwin Cawston provided smaller more cuddly animals for children to sit with and snuggle up to.

The ostriches named Mr. and Mrs. Grover Cleveland lived together as a couple originally at the Norwalk farm. Glover Cleveland was the first Democrat to be elected president since the Civil War. After being defeated for a second term, Cleveland ran again for the presidency four years later and was elected president again in 1894.

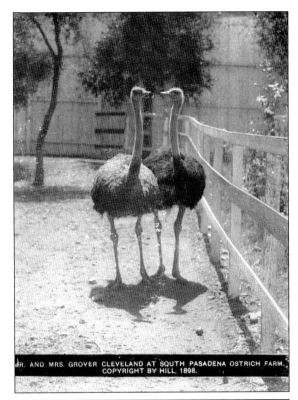

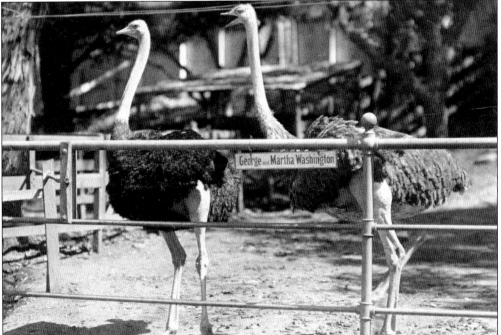

To honor other past presidents, Cawston added George and Martha Washington to his growing ostrich population that were given famous names. In this photograph, it looks like Martha is giving poor George an earful.

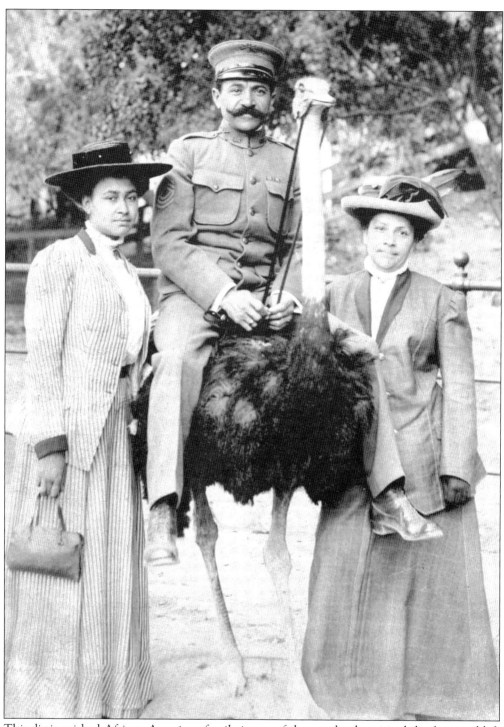

This distinguished African American family is one of thousands who visited the farm and left with a souvenir photograph standing next to an ostrich or sitting on its back. Most of the ostriches were stuffed, but some were live, making for some interesting blurry portraits.

These cute twins pose with their mother on a very weathered-looking stuffed ostrich.

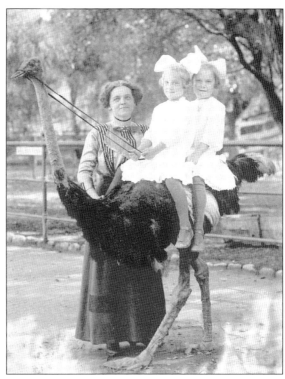

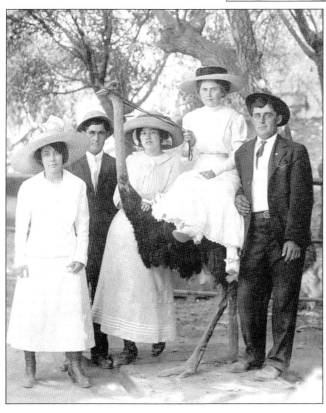

The ostrich in this souvenir group photograph seems to blend in with this handsome bunch.

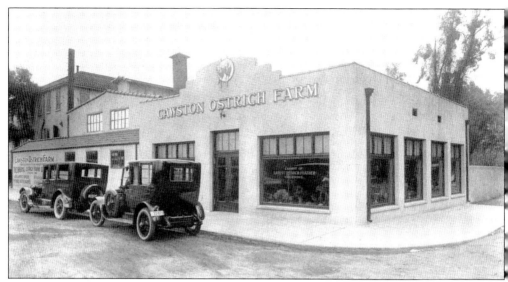

The Cawston Ostrich Farm (with the new salesroom store and gift shop pictured above) was ideally located midway between downtown Los Angeles and Pasadena and was easily accessible by established steam and electric railways or by automobile on freshly oiled dirt roads. The South Pasadena ostrich farm even had its own train stop. From Los Angeles, visitors could take South Pasadena Cars on Main Street marked "Cawston Ostrich Farm." (Courtesy South Pasadena Public Library.)

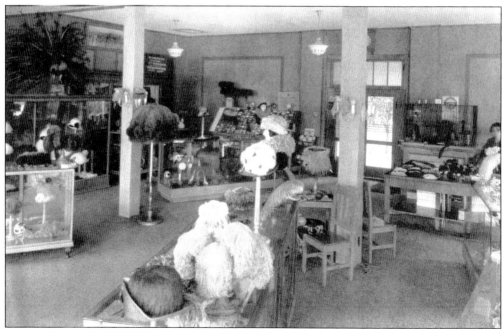

The tour ended on the Cawston salesroom floor and gift shop. Souvenir sales were brisk at the gift shop. Every kind of trinket imaginable had the Cawston mark on it: pocket mirrors, pocket knives, watch fobs, letter openers, paper weights, toothpick holders, match safes, hand-painted plates, tape measures, buttons, spoons, trays of every shape and size, and more. (Courtesy South Pasadena Public Library.)

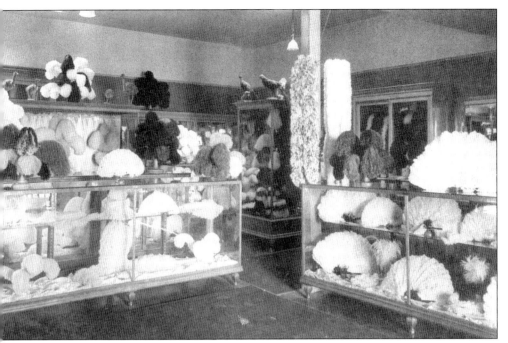

The glass cases on the right contain premium ostrich-feather fans for purchase. On the upper shelf behind the counter on the left are stuffed baby ostriches. (Courtesy South Pasadena Public Library.)

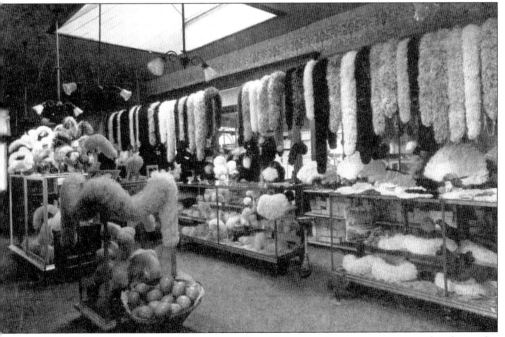

Long racks of boas are displayed for purchase. East Coast tourists were encouraged to leave the names and addresses of their friends back home. The Cawston Ostrich Farm would mail each of them—free of charge—three souvenir postcards and an illustrated Cawston catalogue. (Courtesy South Pasadena Public Library.)

Above are two handmade postcards from the Cawston Ostrich Farm. The card on the left is made of leather, and the card on the right contains real ostrich feathers. Below is a collection of souvenir spoons, a favorite collectible for tourists who visited the ostrich farm. Each of them had an ostrich and reference to the farm in its bowl. On the handle there were interesting designs, symbols, and themes, including flowers, fruit, Native American, and golfer. The most striking handle was a swastika. The Nazi Party's use of the left-facing swastika during World War II made it a controversial and reviled symbol. Prior use of the swastika dates back to Neolithic Eurasia, commonly seen in early Greek civilization and pre-Christian European cultures. The symbol was a popular good luck charm for early aviators. In fact, a left-facing swastika was painted on the inside nose cone of Charles Lindberg's *Spirit of St. Louis* and was present when he made his world famous solo flight from New York to Paris in 1927.

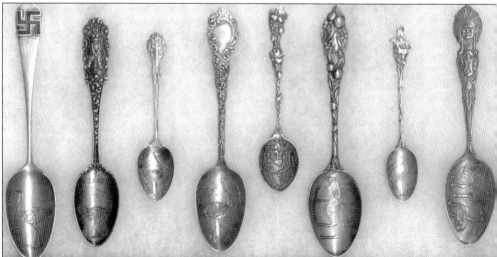

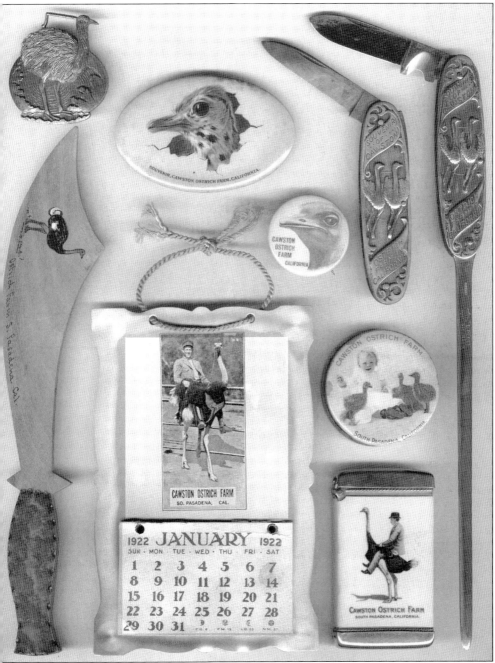

Cawston souvenirs displayed in this photograph (from top left to bottom right) are a watch fob, pocket mirror, pocket knife, pocket knife with letter opener, hand-painted wooden letter opener, button, calendar, tape measure, and match safe. Other popular souvenirs for visitors were photograph postcards of guests sitting bareback on ostriches (either live or stuffed), ostrich plumes sealed in envelopes and boxes, and hollow ostrich eggs that were beautifully hand painted by local artisans.

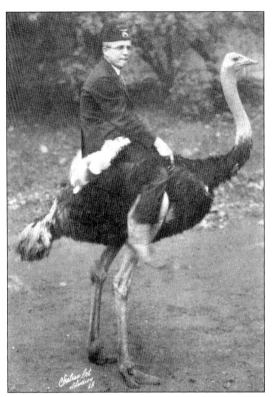

A Shriner sits atop a healthy male ostrich. Note the ostrich's sturdy prehistoric-looking legs—they resemble a T rex dinosaur. Now note the blur of the man's right leg in the photograph. He is actually spurring the ostrich with his heel. Moments after this photograph was taken the ostrich bolted, spilling him off. (Courtesy South Pasadena Public Library.)

This pocket mirror is a souvenir from the Shriners Convention held in South Pasadena, California.

A popular postcard of the Shriners Convention depicts a Cawston ostrich dressed as the Grand Master Shriner.

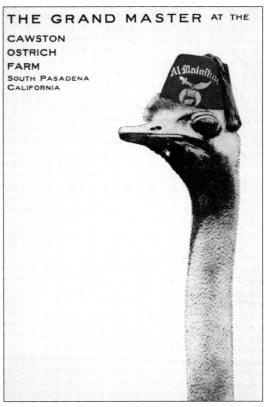

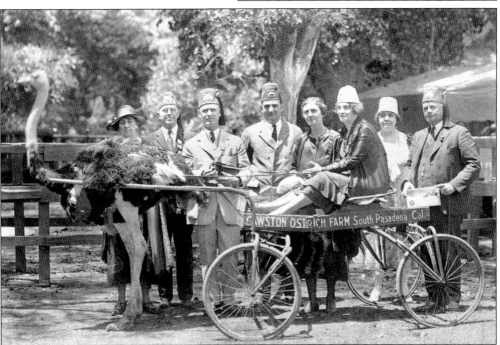

Several Shriners pose for a group photograph taken during their national convention held at the Cawston Ostrich Farm in 1912.

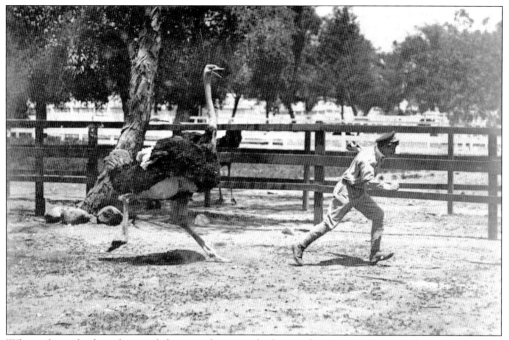

When a large feathered animal the size of an ostrich chases after you—no matter the reason—there is only one thing to do: run for your life!

Being Initiated at the Cawston Ostrich Farm, South Pasadena, Cal., July, 1909.

Apparently the Elks did not fare as well as the Shriners during their national convention at the Cawston Ostrich Farm in 1909.

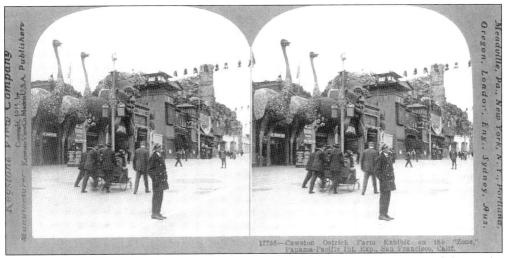

These two giant-sized ostriches mark the entrance to the Cawston Ostrich Farm exhibit on the "Zone" at the San Francisco Panama-Pacific International Exposition in 1915. The world's fair, open from February 20 through December 4 in 1915, gave the city of San Francisco the opportunity to showcase its recovery from the 1906 earthquake. (Note: To view stereographs in 3-D without the aid of a viewer, simply look at the image at a comfortable viewing distance and cross your eyes slowly until the two images merge into one three-dimensional view.)

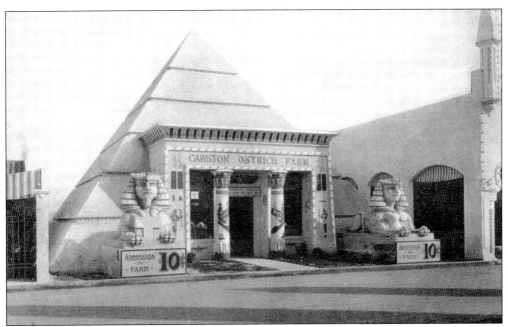

At about the time the San Francisco world's fair was closing, the city of San Diego hosted the Panama-California Exposition. This exposition celebrated the opening of the Panama Canal and ran from March 9, 1915, through January 1, 1917. For 10¢, visitors could enter the Cawston Ostrich Farm exhibit in San Diego, California. The exhibit was described as having a large number of birds with an "alluring and endless variety of feathers to tempt purchasers."

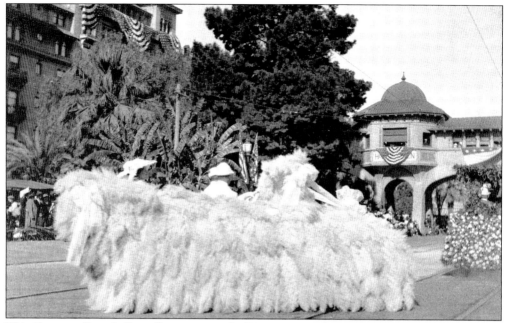

This Cawston Ostrich Farm float entry at the Tournament of Roses parade in Pasadena rounds the corner onto Raymond Street. The Green Hotel can be seen in the background of this early parade route. The Tournament of Roses Committee expanded the parade in later years, using Orange Grove Boulevard and its tributary streets for staging and beginning of the parade.

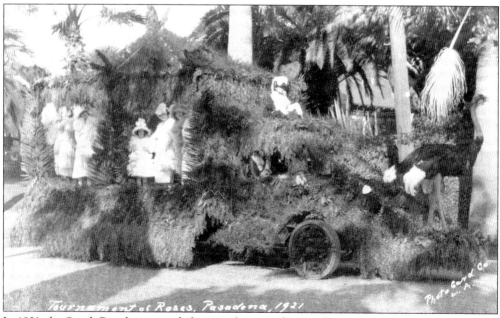

In 1921, the South Pasadena ostrich farm made a grand entry that included famous actresses and a real stuffed ostrich riding on the front of the parade float.

Four
Harnessing the Sun
A Solar Power Success

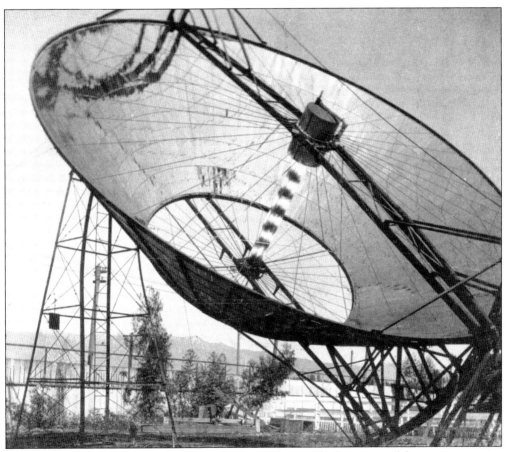

In 1901, the Cawston Ostrich Farm was the site of the world's first successful experiment using a solar-powered motor for commercial use. Aubrey Eneas selected Cawston's Ostrich Farm in sunny South Pasadena to showcase his monstrous parabolic dish and launch his new company, the Solar Motor Company.

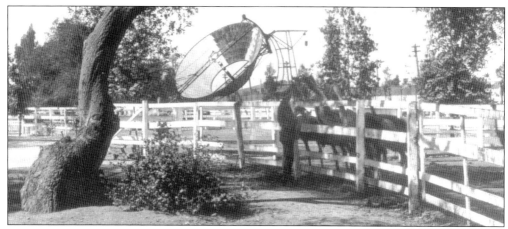

The solar motor consisted of a boiler 13 feet in length and a foot wide, containing 1,000 gallons of water. The solar mirrors were configured to focus concentrated light energy onto the boiler. The water boiled and transferred steam to an engine that pumped 1,400 gallons of water per minute from a deep well on the Cawston Ostrich Farm. Speculation ran high for the future potential of such a plentiful low-cost energy source. One such article titled "Harnessing the Sun," published in 1901 and written by F. B. Millard proclaimed: "Why should we burn costly, hard-delved coal in power-houses, when we can hitch our trolley cars to the sun?"

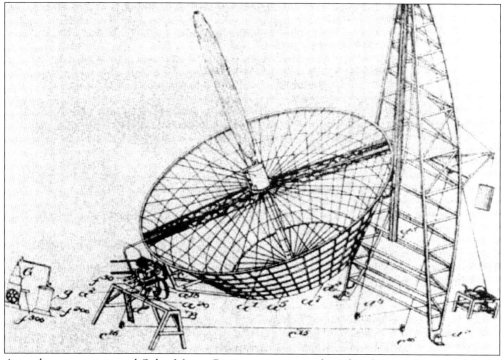

According to an internal Solar Motor Company memorandum dated December 8, 1903, the principle assets of the company were: U.S. Patents Nos. 670, 916, and 917 for solar generators. The solar motor required considerable space and sufficient sunshine to make it viable. With inexpensive fuel production on the rise from easily accessible oil fields, the solar motor was doomed from the start. Furthermore, the solar motors were touted to resist high desert winds, but not the hail storm that destroyed the one in Mesa City, Arizona.

It was an odd site for sure: Edwin Cawston's flock of some 260 strange-looking birds milling around a towering mechanical beast with its 1,788 mirrors flashing in the bright sun. This spectacle lured several newspaper and magazine reporters to the farm. They reported tales of the California ostrich farm to their Midwest and East Coast readers who were hungry for stories about the West. Cawston loved the free publicity, as evidenced by his reprinting their comments in his advertisements, brochures, and catalogues.

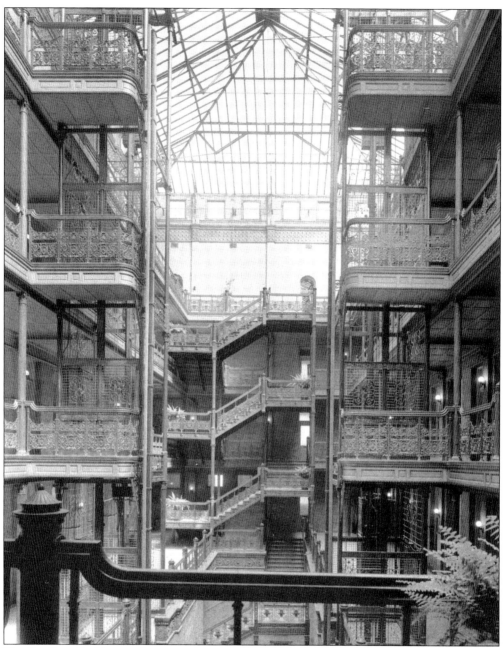

The Bradbury Building in downtown Los Angeles was the West Coast headquarters for the Solar Motor Company during its introduction in 1901. Its massive skylight allowed natural sunlight to pour into the interior of the office building, making the company's case to potential investors for the benefits of solar power to make the world a better place to live.

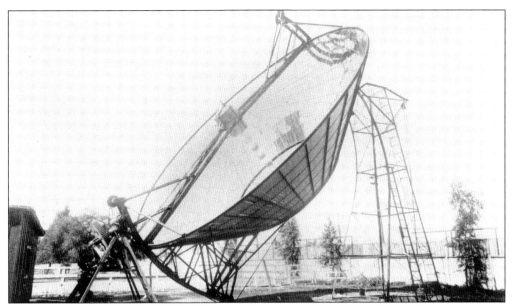

The umbrella-like dish is heavily ribbed with steel and cradled in a tall iron framework, like that set up for windmills. Under the bottom of the dish is an equatorial mounting, similar to the yoke-action apparatus used with large telescopes. The solar motor is balanced, the weight distributed evenly over roller bearings so that only slight hand pressure is required to move it into position—setting the initial focal point on the sun for automatic tracking throughout the day. (Courtesy California Historical Society.)

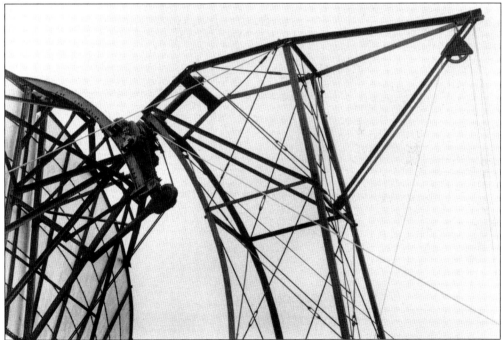

Note the pulleys and cables utilized in this design to take full advantage of the physics of leverage to move the mirror-laden heavy dish easily in its iron "cradle" framework. (Courtesy California Historical Society.)

```
                    Solar Motor Company,
                        186 Devonshire Street,              418

  Cable Address
   "Solarmotor"    COPY.       Boston,    April 20th., 1903.
(Western Union Code)

Chas. J. Rice, Esq.,
    Denver, Colorado.

Dear Sir:-
            Mr. Haskell has asked me to reply to your favor of March
25D.    To convert 700 gallons of water per day of ten hours by
the usual method of a coal-fired boiler will require a 20-H.P. boil-
er costing about $600. the expense per annum of operating which
will be:-Coal at $20. per ton......$1,800.00
            Attendance...............   365.00
                                     ---------
                                     $2,165.00

        We can supply you with three of our Solar Generators, includ-
ing boilers, for $7,200. the expense per annum of operating which
will be:- Fuel....................... $ 0.00
          Attendance................   55.00
                                       -------
                                       $55.00

        From these figures you can easily see the great advantage of
our system charging whatever reasonable interest on original invest-
ment.    These estimates are in both cases f.o.b. Boston.   The cost
of installation and putting into operation will be about $500.00

        Trusting to be favored with your orders, We are,

                        Yours truly,

                        SOLAR MOTOR COMPANY,

                            W. H. Jaques.

                                General Manager.
```

This letter from the Boston office, dated April 20, 1903, compared the relative cost of producing power using coal and solar power (produced by the solar motor). The letter states the cost per year for coal to run a motor, which pumps 700 gallons of water a day, is $2,165 a year. After the initial expense of $7,200 to build the solar motor, the fuel used to run it is $0 (although there was a $55 attendance fee) per year. The Solar Motor Company had a motto, which they repeated frequently: "SUN is our FUEL."

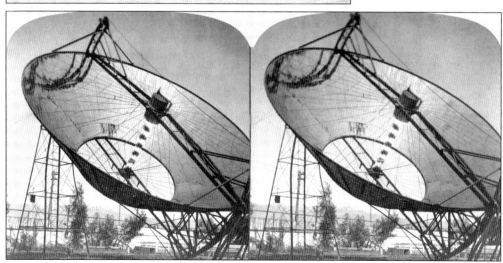

This stereograph photograph offers the best picture of the solar power experiment as a three-dimensional view.

In 1902, an article titled "A Successful Solar Motor" was published by *Applied Science: Invention and Industry* describing the solar motor in "flowery terms": "When the focus is obtained, the solar motor acts like a sunflower, automatically keeping its shining face toward the sun. Here, too, the inventors had learned a lesson from astronomers, for common clocks are made to do duty as regulators. The morning dew is seen slowly to ascend in a wreath of vapor from the gigantic mouth of the solar motor."

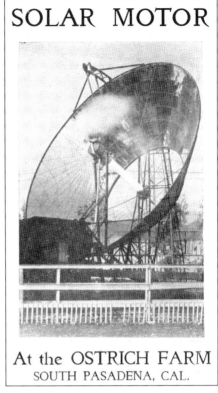

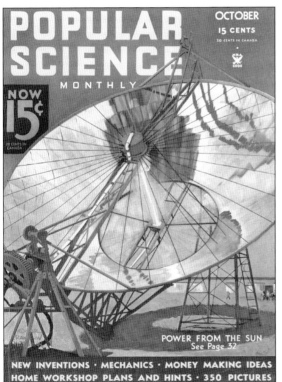

The *Popular Science* monthly magazine featured the solar motor at the Cawston Ostrich Farm on its October 1934 cover.

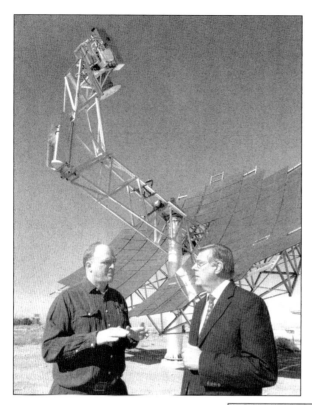

The same solar power experiments are being conducted today at Sandia's National Solar Test Facility, where concentrated solar energy is used to power a solar motor. Sandia researcher Chuck Andraka (left) talks with Bob Liden, Stirling Energy's executive vice president and general manager. Stirling and Sandia have announced plans to build a solar dish engine plant. (Courtesy Sandia National Laboratories.)

Research continues at Sandia National Laboratories to test six new solar dish-engine systems for electricity generation that will provide enough grid-ready solar electricity to power more than 40 homes. The ultimate goal is to deploy solar dish farms with 20,000 units producing energy. (Courtesy Sandia National Laboratories.)

Five
High Fashion
Royalty and the
New Mail-Order Gentry

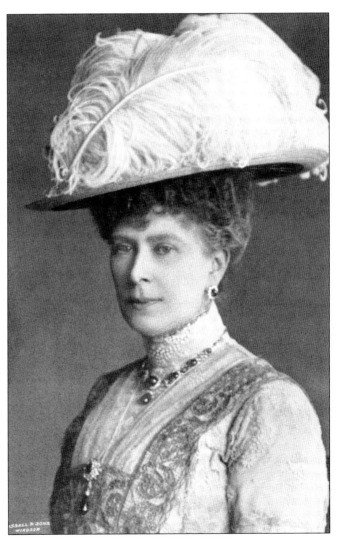

Ostrich feathers were the high fashion of royalty, as seen on the lovely Queen Mary.

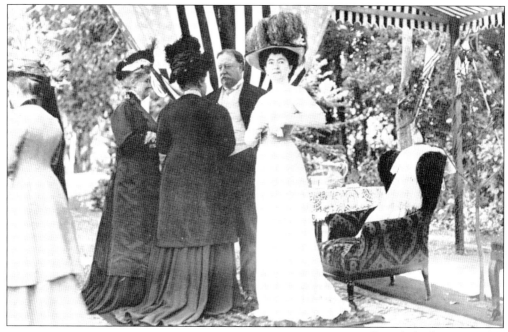

Ostrich feathers were the high fashion of American wealth and privilege. Carrie Bell Reed (right), wife of Tom Walsh, the man who struck it rich with the Camp Bird gold mine, hosts Pres. and Mrs. William Howard Taft at her home. In Europe, the Walshes entertained King Leopold of the Belgians, who invested in Walsh's mine. The Walsh's daughter, Evalyn, later became the owner of the 45-carat Hope Diamond and the 94-carat Star of the East. (Courtesy Library of Congress.)

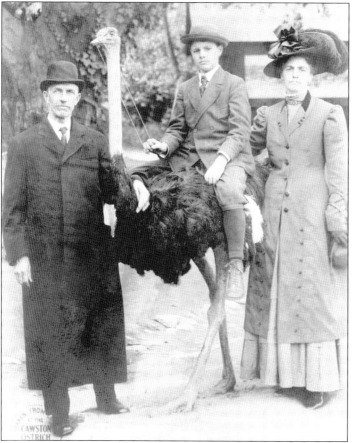

These fashionable visitors to the Cawston Ostrich Farm look as though they belong at a dinner affair hosted by the Vanderbilts in Newport, Rhode Island.

Edwin Cawston offered American women the opportunity to dress like royalty at an affordable price. He only sold ostrich plumes of the finest quality and only sold them direct to consumers, cutting out the middle man.

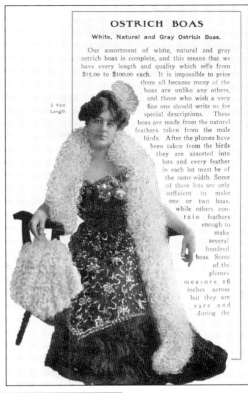

OSTRICH BOAS
White, Natural and Gray Ostrich Boas.

Our assortment of white, natural and gray ostrich boas is complete, and this means that we have every length and quality which sells from $15.00 to $100.00 each. It is impossible to price them all because many of the boas are unlike any others, and those who wish a very fine one should write us for special descriptions. These boas are made from the natural feathers taken from the male birds. After the plumes have been taken from the birds they are assorted into lots and every feather in each lot must be of the same width. Some of these lots are only sufficient to make one or two boas, while others contain feathers enough to make several hundred boas. Some of the plumes measure 16 inches across but they are rare and during the

2 Yard Length

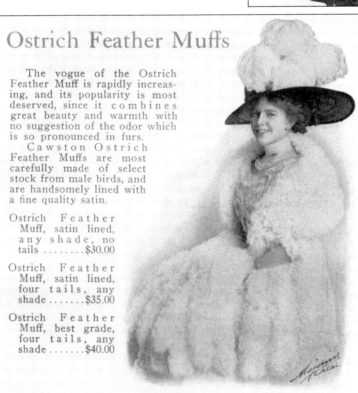

Ostrich Feather Muffs

The vogue of the Ostrich Feather Muff is rapidly increasing, and its popularity is most deserved, since it combines great beauty and warmth with no suggestion of the odor which is so pronounced in furs.
Cawston Ostrich Feather Muffs are most carefully made of select stock from male birds, and are handsomely lined with a fine quality satin.

Ostrich Feather Muff, satin lined, any shade, no tails$30.00

Ostrich Feather Muff, satin lined, four tails, any shade$35.00

Ostrich Feather Muff, best grade, four tails, any shade$40.00

Cawston acquired models that looked like the average American woman, they were young and old but typically common in appearance. He would then cover them from head to toe in ostrich feathers.

79

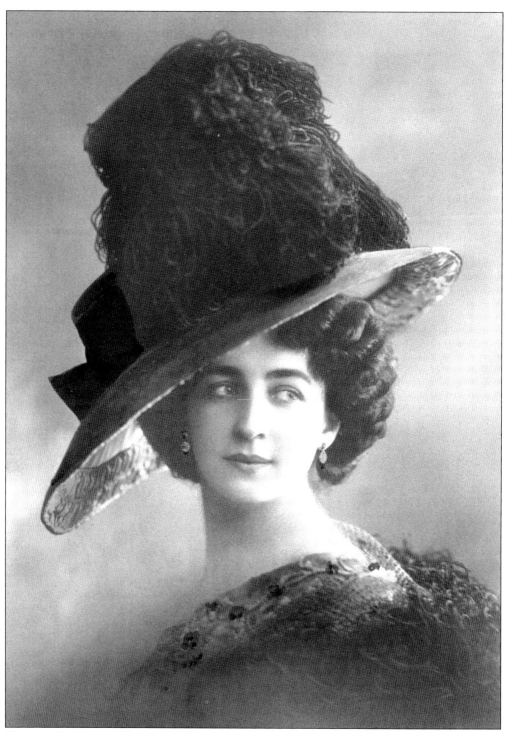

This smartly appointed dresser would be the hit at anyone's high-class affair. Edwin Cawston would have said that any woman could be just like her because ostrich feathers were now affordable for the general public like no other time in history.

Spring hats from Paris, trimmed with an ostrich plume, were not only affordable, but Edwin Cawston also took the hassle out of acquiring them. All his products could be obtained in one of three easy ways: by mail order, in person at the farm, or at the boutique downtown.

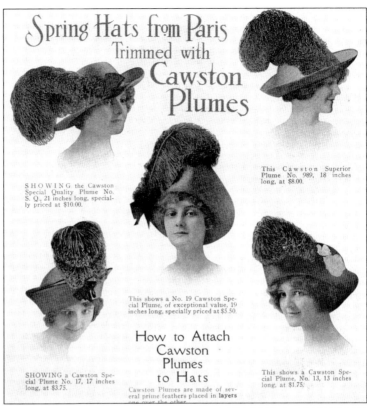

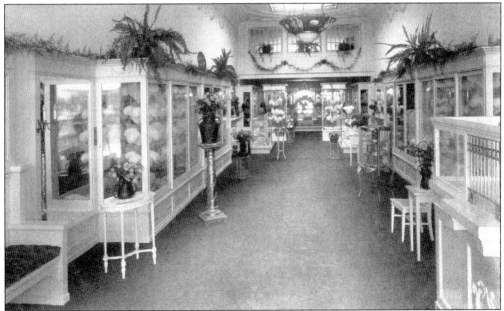

The Los Angeles store interior was an experience of sheer elegance for its size. Edwin Cawston never sacrificed quality or downplayed the high-fashion application of his ostrich feathers. He simply played himself off as the benevolent benefactor to women. He imagined himself as the instrument of good fortune to his customers. (Courtesy South Pasadena Public Library.)

81

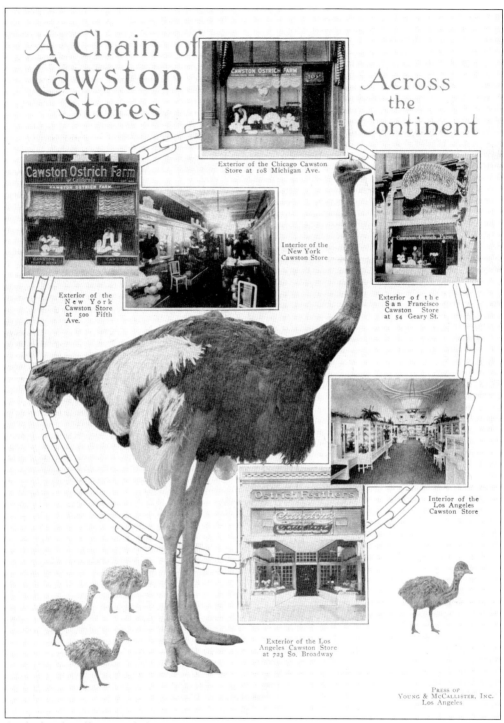

At the height of his ostrich farm's success, Cawston retail stores were opened in many of the larger cities, including New York, Chicago, San Francisco, and Los Angeles.

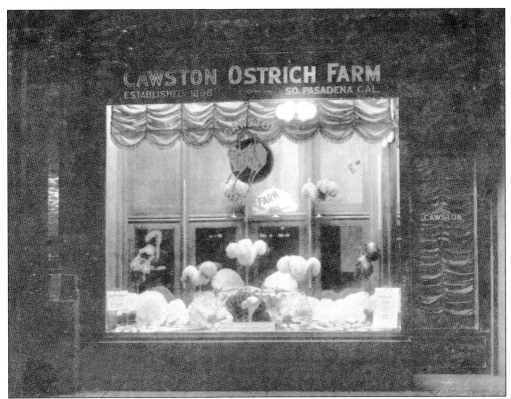

Pictured here is the storefront of Cawston's ostrich feather boutique located at 108 Michigan Avenue in Chicago. (Courtesy South Pasadena Public Library.)

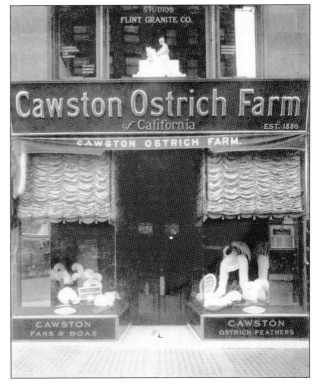

Cawston's storefront in New York City was located at 500 Fifth Avenue. (Courtesy South Pasadena Public Library.)

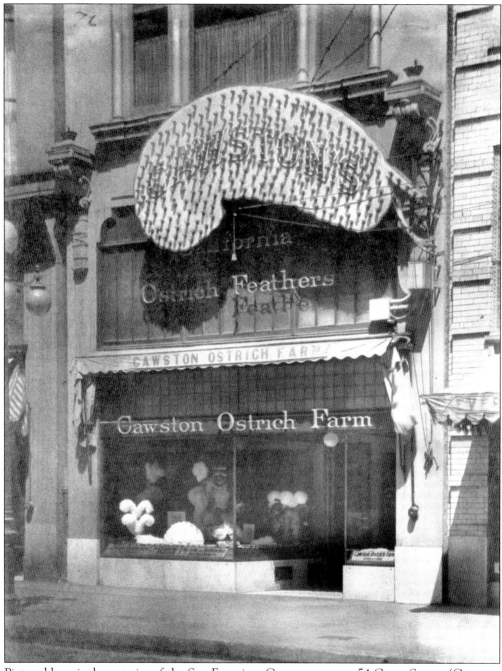
Pictured here is the exterior of the San Francisco Cawston store at 54 Geary Street. (Courtesy South Pasadena Public Library.)

NOTICE

For the convenience of those who have not had an opportunity of visiting the Cawston Ostrich Farm at So. Pasadena, we have established a Store in Los Angeles, where the famous Cawston Ostrich Plumes can be purchased at producer's prices.

313 South Broadway

Ville de Paris Next Door

Write for FREE Illustrated CATALOG

Portraits of Ostriches are very difficult to obtain. This one is the best in existence

CAWSTON OSTRICH FARM, South Pasadena, Cal.

This postcard was sent to the public announcing the opening of the Los Angeles Cawston store.

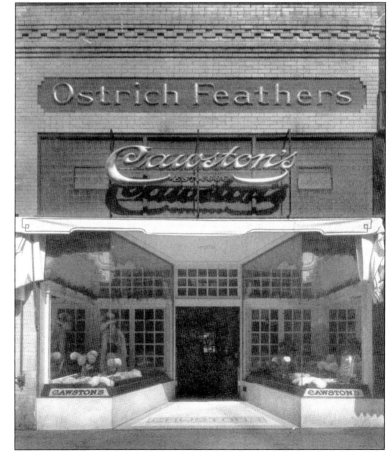

This elegant storefront was Cawston's final ostrich feather boutique in his chain. This Cawston store was located on South Broadway next door to Ville de Paris. (Courtesy South Pasadena Public Library.)

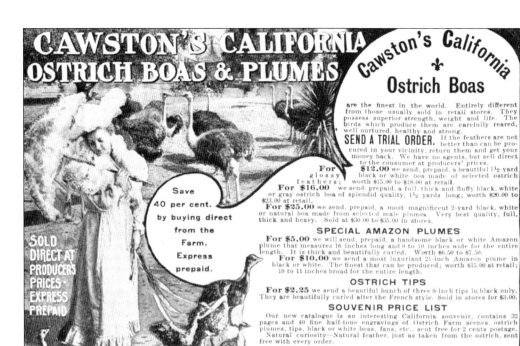

To promote his burgeoning mail-order business, Edwin Cawston mailed thousands of catalogs and placed advertisements in many of the largest national publications.

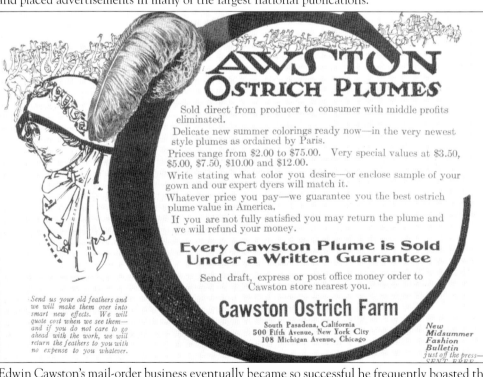

Edwin Cawston's mail-order business eventually became so successful he frequently boasted that he received more mail to his South Pasadena address than anyone in California.

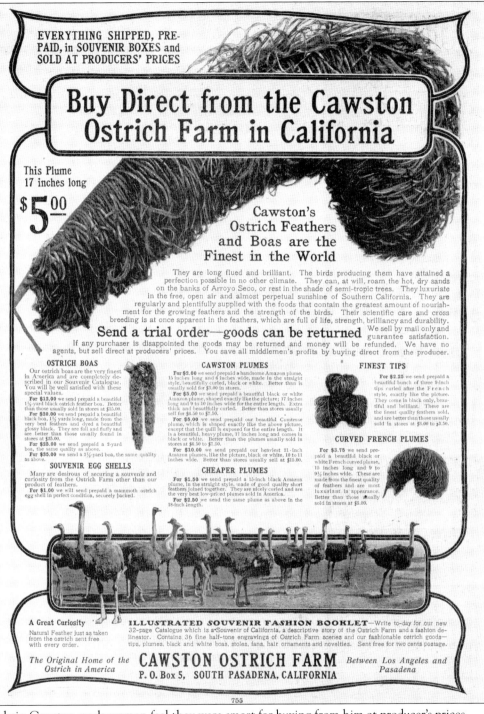

Edwin Cawston made women feel they were smart for buying from him at producer's prices.

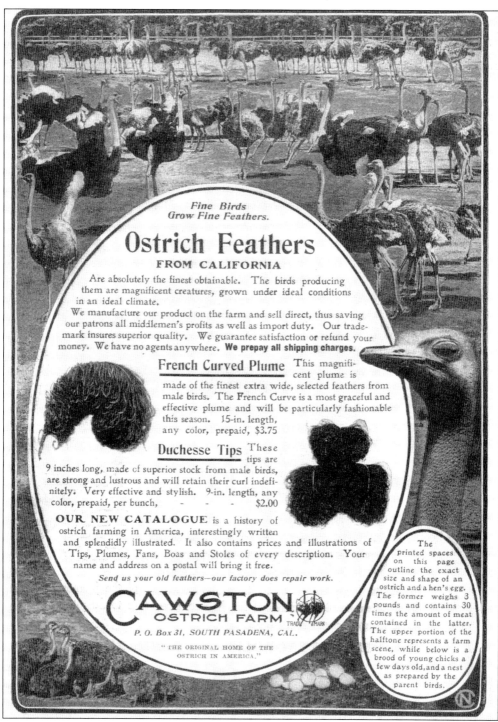

Edwin Cawston always included educational information about the ostriches and their feathers in his catalogues and newspaper advertisements. He felt that educating the public was the key to his success. In this advertisement, he compares the relative size difference of a hen's egg and an ostrich egg.

Advertisements placed regionally in daily newspapers took on a more urgent tone; such is the nature of brick-and-mortar retail sales.

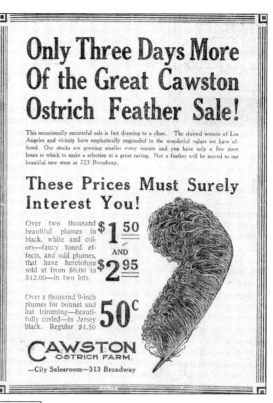

During one Christmas season, Edwin Cawston stated: "I receive more mail here at the farm than Santa Claus."

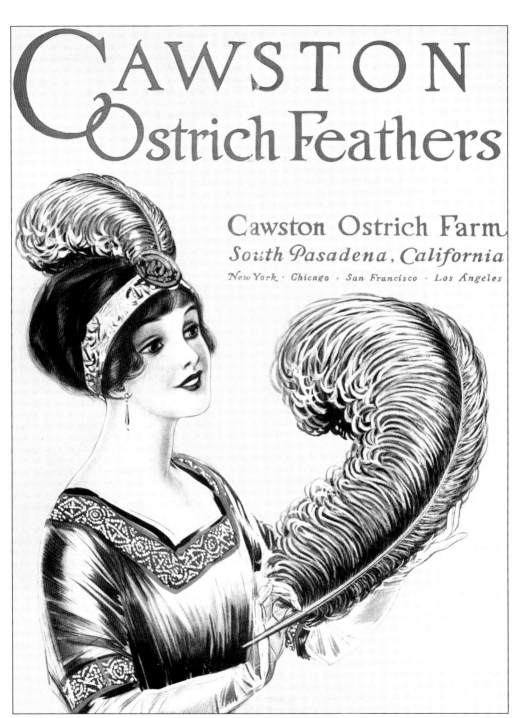

Edwin Cawston's catalogue covers showed intelligent-looking models with a certain refinement.

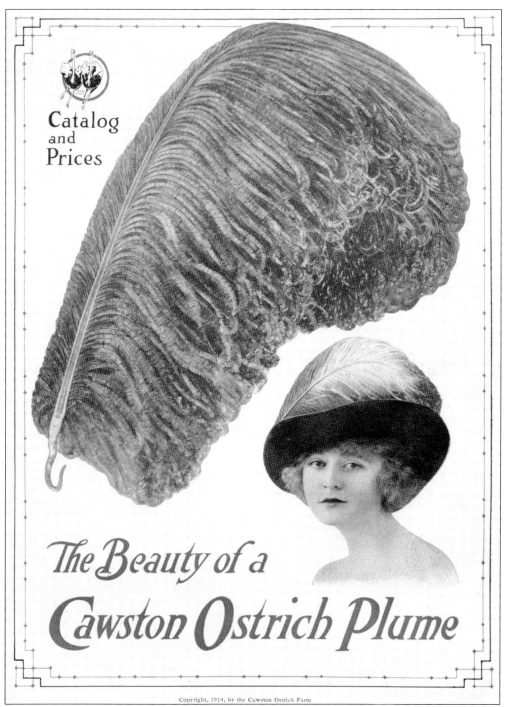

The ostrich feather plume was often featured as an object of admiration or prominence next to the model on the cover. Within the first couple of pages, a variety of plumes were explained for their distinct characteristics and use.

Ostrich Feather Boas

NO article of dress ever fashioned gives so beautiful a touch of completeness to milady's costume as an ostrich feather boa or stole. For evening wear they are particularly stunning. They are alike an ideal light wrap for summer—and possessed of unusual warmth for winter wear.

They have been and will continue to be worn by the world's best gowned women.

These moderate priced boas, shown in the illustration, are made of carefully selected stock, of uniform strength and brilliancy, and have given universal satisfaction to thousands of our customers in all parts of the world.

No. 103, 1½ yards long (special) . $10.00
No. 123, 1½ yards long 12.00
No. 163, 1½ yards (better quality) . 16.00
No. 203, 1½ yards (extra full and large) 20.00
No. 155, 2 yards (special) 15.00
No. 255, 2 yards, medium, exceptional value 25.00

Delivery prepaid

Above prices include black, white or any solid color. For natural colors see page 5.

We deliver free everywhere

Boas for Little Girls

SOMETHING new to enhance the young lady's charm and furnish needed protection about the neck. Simple neck boas, with ribbons to tie at the throat. Boas, 12 inches long, black, white and colors $1.50

Delivery prepaid

Ostrich Feather Stoles

THE accompanying illustration gives but slight idea of the beauty and grace of these very fashionable stoles.

They are made of two or three strands of prime Cawston Ostrich Feathers, invisibly joined together to give a broad, flat effect.

Only very choice stock is used—they are beautifully curled —can be repeatedly cleaned, recurled or re-dyed—and will wear a life-time.

Like the ostrich feather boas—these stoles can be worn in summer as well as winter—with tailored suit, street dress or evening gown.

No. 2025, 2 yards, 2 strands $20.00
No. 2535, 2 yards, 3 strands 25.00
No. 2527, 2½ yards, 2 strands . . . 25.00
No. 3029, 3 yards, 2 strands 30.00
No. 5039, 3 yards, 3 strands 50.00

Delivery prepaid

Above prices include black, white or any solid color. For natural colors see page 5.

We have no agents— we sell direct.

Side by side, this Cawston advertisement explained the difference between boas and stoles.

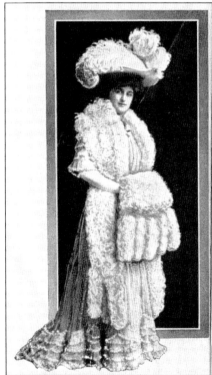
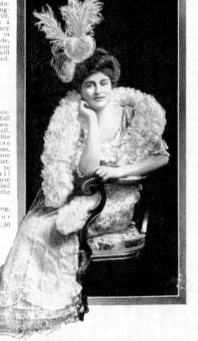

We carry in stock some exceedingly handsome Boas not listed in this catalogue, at prices ranging up to $100.00. Should you desire a Boa of extraordinary proportions or of some unusual shade, write us what you wish, and prices will be promptly furnished.

Boas for Little Girls

In striking contrast to our long, full Boas for the grown-ups, are the small, dainty affairs for the little folks. These are simply neck Boas, finished with ribbon to tie at the throat. Something new to enhance the small young lady's charm and supply needed protection about the neck.

Boas, 12 inches long, pink, blue or white $1.50

This catalogue page shows the same model dressed in a variety of Cawston products. But more importantly, note the text referring to "Boas for little girls." Edwin Cawston was acutely aware that growing the youth market was critical for his long-term success.

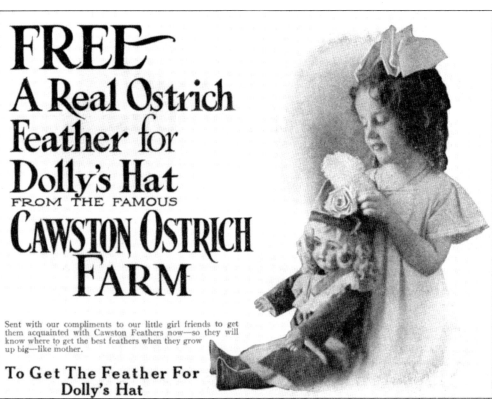

FREE
A Real Ostrich Feather for Dolly's Hat
FROM THE FAMOUS
CAWSTON OSTRICH FARM

Sent with our compliments to our little girl friends to get them acquainted with Cawston Feathers now—so they will know where to get the best feathers when they grow up big—like mother.

To Get The Feather For Dolly's Hat

This popular magazine advertisement was targeted at girls who would tug at their mother's dress and urge them to correspond with Edwin Cawston. They were placed on a mailing list and courted for future sales. At least that is how it was supposed to play out. However, Cawston miscalculated his own success with this particular advertisement offer.

```
Dear little Friend:-

                    Your request for a dolly
plume reached us after our supply of one hundred
thousand had been exhausted, and we are in con-
sequence, unable to send you one.

We regret that you will have cause for disappoint-
ment, but as we have no more of this stock we are
unable to manufacture any more Dolly Plumes.

                    Yours sincerely,

                    CAWSTON OSTRICH FARM.
```

This note was typed up and hastily sent to thousands of disappointed children after the farm's supply of Dolly Plumes was exhausted. In this case, Edwin Cawston was a victim of his own success.

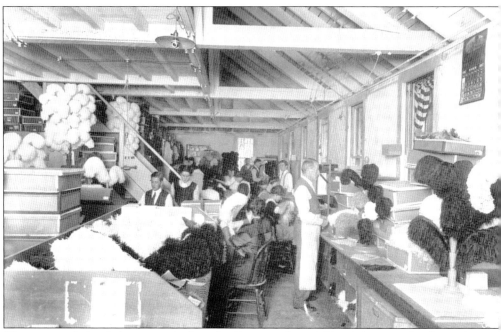

This is a rare behind-the-scenes look at the Cawston Ostrich Farm's busy mail-order packaging and shipping area. (Courtesy South Pasadena Public Library.)

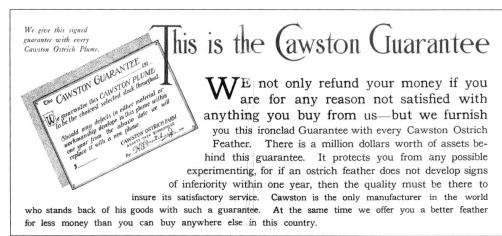

This is the Cawston Guarantee

We give this signed guarantee with every Cawston Ostrich Plume.

WE not only refund your money if you are for any reason not satisfied with anything you buy from us—but we furnish you this ironclad Guarantee with every Cawston Ostrich Feather. There is a million dollars worth of assets behind this guarantee. It protects you from any possible experimenting, for if an ostrich feather does not develop signs of inferiority within one year, then the quality must be there to insure its satisfactory service. Cawston is the only manufacturer in the world who stands back of his goods with such a guarantee. At the same time we offer you a better feather for less money than you can buy anywhere else in this country.

Every Cawston sale came with a signed guarantee to replace any feather if defects developed within one year from the date of purchase. Edwin Cawston shipped all his feather products free of charge. He would have loved the Internet.

Kind to Our Ostriches

Feathers from California Birds May be Worn Without Compunction by Humane Women

(By direct wire to The Los Angeles Times)

YORK (Pa.), Jan. 9, 1906—(Exclusive Dispatch)—Without leaving themselves open to a charge of heartlessness, women may wear ostrich feathers, provided they come from the farm in California. This was the dictum of Mary E. Lovell, General Secretary of the Pennsylvania Society for the Prevention of Cruelty to Animals, delivered before the Young Woman's Club today.

"I can vouch for these feathers," said Miss Lovell, "for I have visited the ostrich farm in California and found that there was no cruelty practiced there."

We have 250,000 satisfied mail-order customers. Are you one?

Edwin Cawston left no stone unturned when it came to educating his prospective buyers. In one catalogue, he addresses any concerns one may have for the humane treatment of his ostriches.

Omaha, 1898

Portland 1905

Cawston Ostrich Feathers

ARE THE BEST IN THE WORLD

Have taken 1st Prizes wherever exhibited

Paris, 1900

Jamestown, 1907

Buffalo, 1901

St. Louis, 1904

Seattle, 1909

Prize-winning superior quality was a hallmark of a Cawston plume. It was the fundamental selling feature the entire business was based on.

Pictured here is the classic ostrich feather fan in a box with the Cawston label.

This Cawston Trademark is attached to every Cawston Ostrich Feather product. Always look for it.

The Cawston trademark was the mark of excellence in manufacturing and customer service. According to the Cawston catalogue: "Cawston uses nothing but selected male-bird feathers. Inferior feathers and those from female birds are sold to other manufacturers. Furthermore, Cawston employs no child labor. None but the most expert adult operators are allowed in the Cawston factories."

Six

FEATHERS OF STAGE AND SCREEN
THAT'S ENTERTAINMENT!

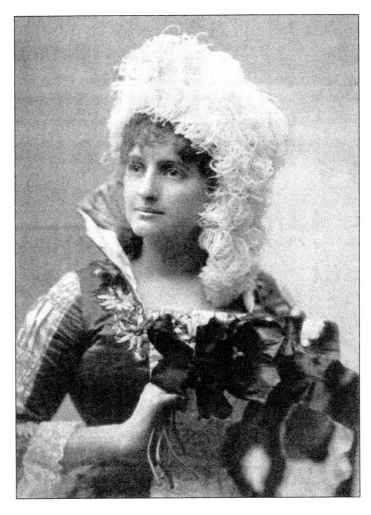

American stage actress Alice Atherton poses for this studio portrait wearing an ostrich feather headdress. (Courtesy Billy Rose Theater Collection; the New York Public Library for the Performing Arts.)

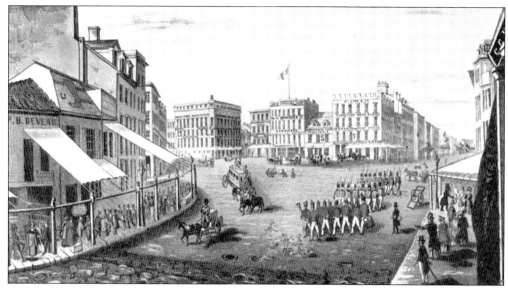

This Currier and Ives print of New York's Chatham Square is where many of the great early theaters were located. (Courtesy Library of Congress.)

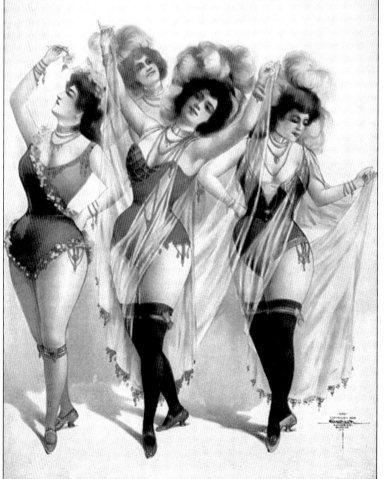

These burlesque dancers would have performed on stage in the Chatham Square theater district. Note the stage production particulars of matching brief costumes, holding veils, and tufts of ostrich feathers in their hair. (Courtesy Library of Congress.)

In 1901, Fred Hamlin's production of The Wizard of Oz featured a chorus line dance troop called the Gaiety Dancers. The dancers wore revealing off-the-shoulder dresses and huge black ostrich plumes on their headdress. (Courtesy Library of Congress.)

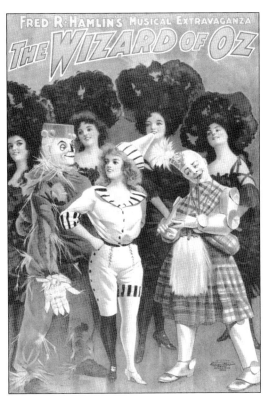

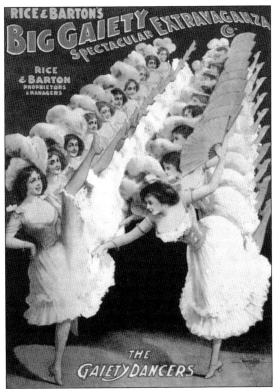

The Gaiety Dancers were featured in Rice and Barton's Big Gaiety burlesque show, featuring pantomime, magic, special effects, and a huge chorus line wearing large ostrich plumes. These "spectacular extravaganzas" were wildly successful in their day. (Courtesy Library of Congress.)

Madame Modjeska poses with her ostrich feather fan for this studio photograph. Modjeska was a renowned Polish actress who specialized in Shakespearean roles. She came to Pasadena in 1889 and purchased a ranch near Anaheim with her husband. (Courtesy Billy Rose Theater Collection, New York Public Library for the Performing Arts.)

The Grand Opera House in Pasadena opened on the evening of February 13, 1889, "with the most fashionable audience ever gathered together in Pasadena." The high point of the theater's short-lived career came three weeks later when Madame Modjeska starred in *Mary Stuart* and then in *Camille*. (Courtesy archives at the Pasadena Museum of History.)

The great American stage actress Lillian Russell poses for this promotional photograph wearing a manacle and a hat with two large black ostrich plumes. (Courtesy Library of Congress.)

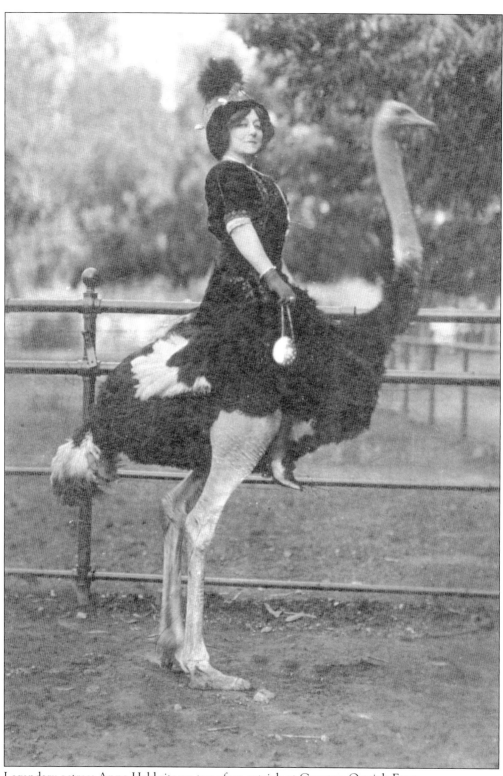
Legendary actress Anna Held sits on top of an ostrich at Cawston Ostrich Farm.

Actress Anna Held performed on Broadway, in silent films, and for soldiers at the front during World War I. (Courtesy Library of Congress.)

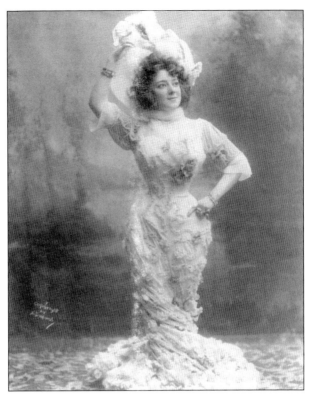

This postcard says it all—the Cawston Ostrich Farm was a major supplier of ostrich feathers and specialty-designed clothing for actresses of the stage and film. The farm enjoyed the publicity, and the actresses loved to pose in specially made extravagant feather fashion.

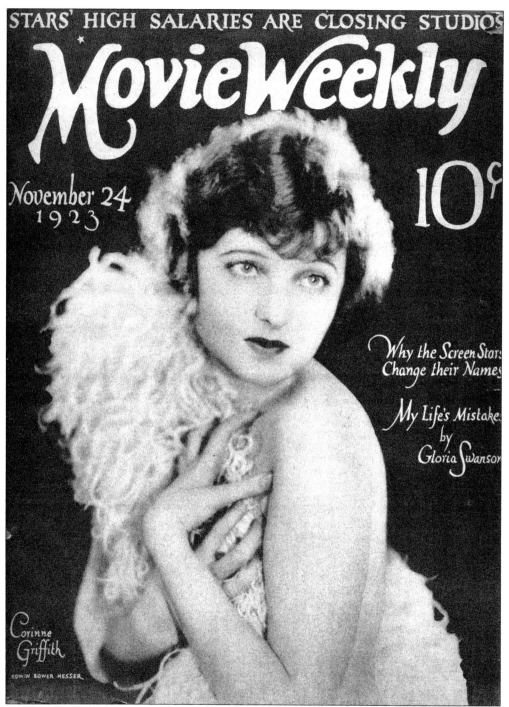

In 1923, actress Corrine Griffith is featured on the cover of *Movie Weekly* hugging a large ostrich feather plume.

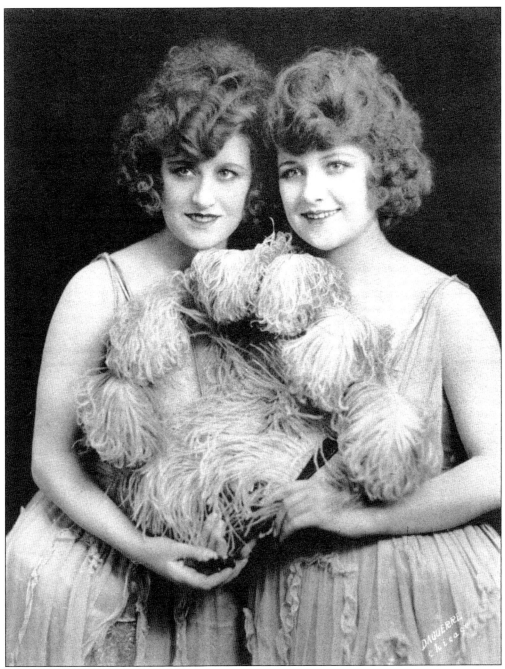

The Swanson Sisters were a famous vaudeville act in the early 20th century that specialized in ostrich-feather fan dances and magic.

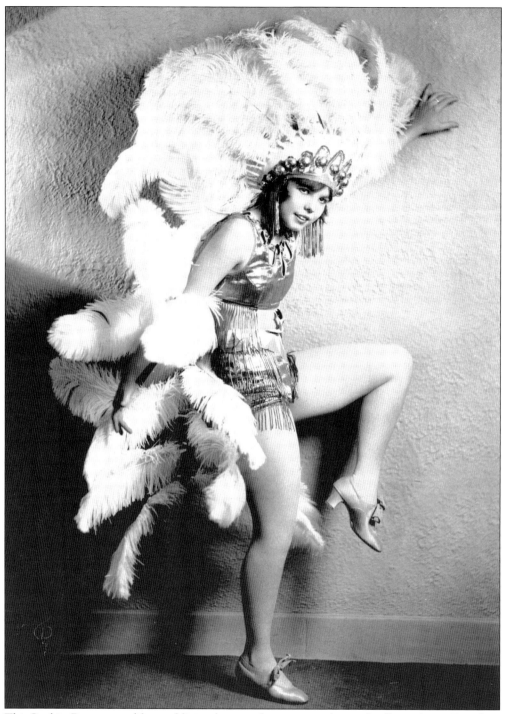
This Sunkist Beauty posed for a publicity photograph promoting the vaudeville producers Franchon and Marco's production of the extravaganza *Indian Summer Idea*.

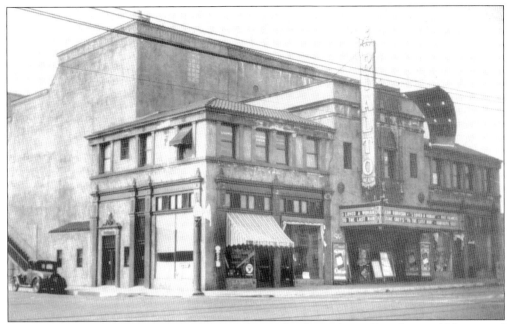

According to local historian Glen Duncan, "The vaudeville producers Franchon and Marco used the Rialto theater in South Pasadena as an important tryout stage for new talent before booking them into their top house, the Paramount in Los Angeles."

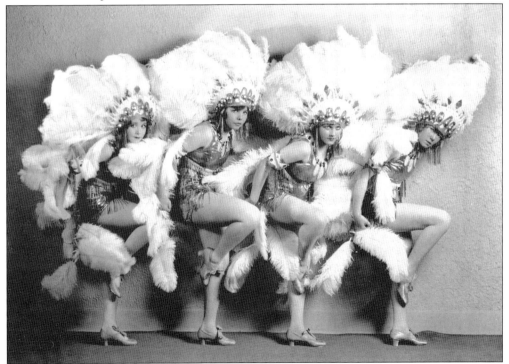

In 1927, the Franchon and Marco's vaudeville show featuring the Sunkist Beauties performed at the Rialto Theater in South Pasadena. The Cawston Ostrich Farm supplied the ostrich feather plumes for the dance troop's extravaganza *Indian Summer Idea*.

Actress Helen Jerome Eddy (center) flew down to South Pasadena from her home in Santa Barbara to visit the Cawston Ostrich Farm in 1920. Herbert Vatcher, superintendent of the ostrich farm (right), poses with Eddy and his son Herbert Jr. (left). (Courtesy South Pasadena Public Library.)

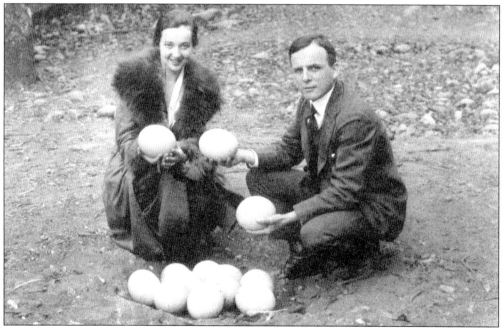

Helen Jerome Eddy and Herbert Vatcher Jr. pose with ostrich eggs at the Cawston Ostrich Farm in South Pasadena, California. Eddy began her acting career during the silent film era and went on to appear in such films as *Strike Up the Band* and *Mr. Smith Goes to Washington*. Vatcher served as the farm's president and general manager. (Courtesy South Pasadena Public Library.)

Blanche Sweet poses with a large ostrich feather for this dramatic photograph. Sweet was a famous silent-screen actress renowned for her energetic, independent roles. This was a departure from the common image of women in film at the time, which portrayed the lead female character as vulnerable and fragile.

Actress Dorothy Dwan rests a large ostrich feather plume on her shoulder while posing for this promotional photograph. Her handwriting on the photograph reads: "With best wishes to Cawstons, Dorothy Dwan." (Photograph by Bert Rosenthal.)

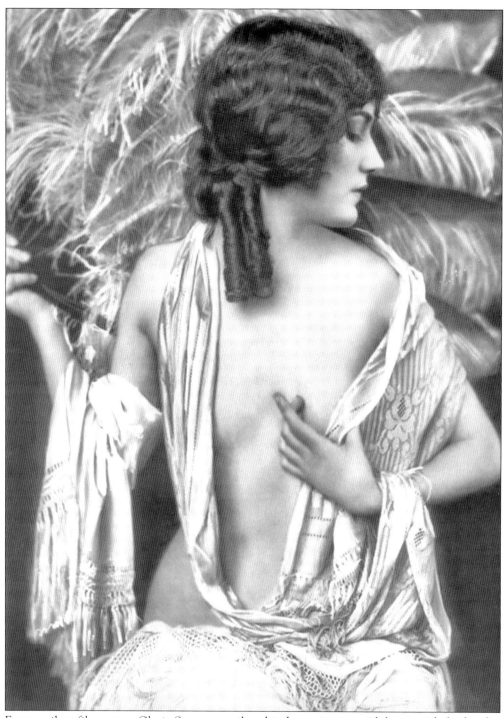
Famous silent-film actress Gloria Swanson strikes this dramatic pose with her ostrich-feather fan as backdrop.

This ostrich-feather cape provided by the Cawston Ostrich Farm was worn by actress Blanche Le Clair for her publicity shoot. (Photograph by Clarence Sinclair Bull.)

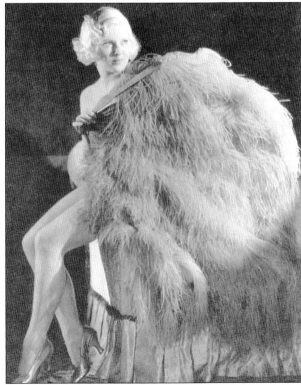

Popular film actress Jean Harlow poses with a large ostrich-feather fan supplied by the Cawston Ostrich Farm. (Photograph by Harvey White.)

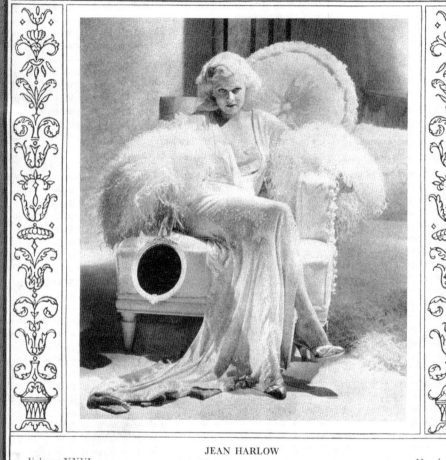

On the cover of *Time* magazine, Jean Harlow declares: "Fine feathers make fine fans."

Seven
LOCAL TOURIST ATTRACTIONS
GARDENS, LIONS, AND RAILROADS

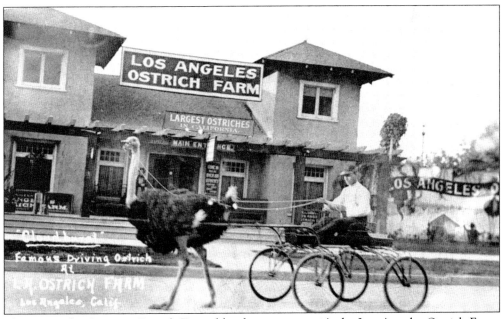

This is not the Cawston Ostrich Farm; like the sign says—it's the Los Angeles Ostrich Farm. Several ostrich farms sprung up overnight in the wake of Edwin Cawston's successful venture in South Pasadena. The more notable farms were located in Los Angeles, San Diego, and San Jose, California; Jacksonville and St. Augustine, Florida; and Hot Springs, Arkansas. At the Jacksonville ostrich farm, tourists were treated to ostrich-buggy races in addition to the regular factory tours and viewing of ostrich livestock. Each farm had to outdo the other. To differentiate itself from other farms, the Los Angeles Ostrich Farm claimed it had the largest ostriches in California.

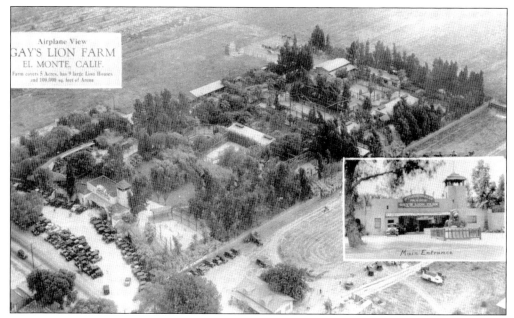

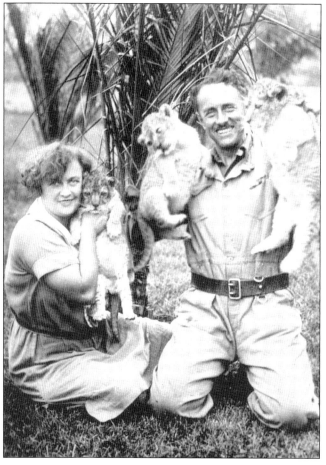

A popular attraction located in nearby El Monte was Gay's Lion Farm. The farm had over 100,000 square feet of arena to showcase lion acts for the paying public. Charles Gay would ride lions bareback (sound familiar?) to show his ultimate domination of man over beast. His lions, used in the Tarzan movies, drew thousands of tourists for over 20 years until the outbreak of World War II.

Charles and Muriel Gay ran Gay's Lion Farm together and enjoyed their work. Charles suffered serious lion bites during his career but managed to survive the worst of them.

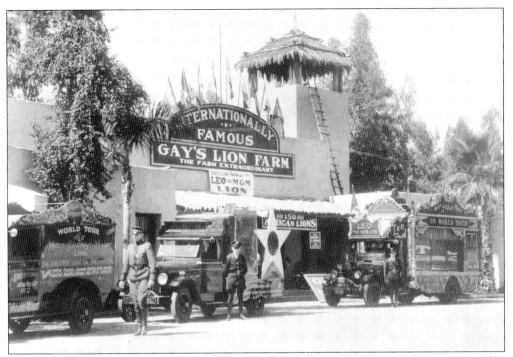

One of the farm's most famous lions was used as the MGM side-profile trademark for the studio. Leo, the MGM lion, made his first stop at the internationally famous Gay's Lion Farm on a world tour to promote the movie studio.

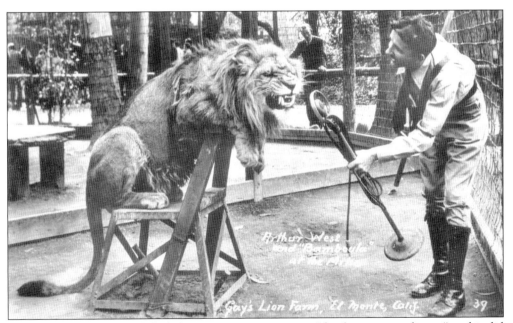

Charles and Muriel Gay billed their unique attraction as "the farm extraordinary," and it did not disappoint.

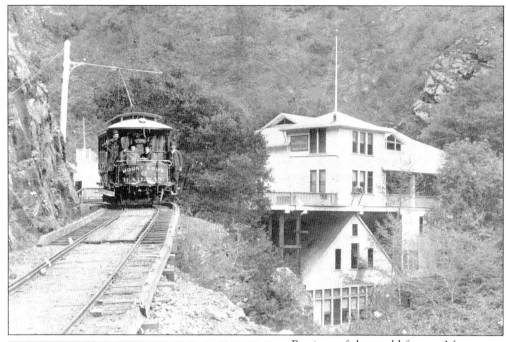

Portions of the world-famous Mount Lowe Railroad could be seen from the Cawston Ostrich Farm. In this view, the electric car is returning from Rubio Canyon. At the right is the Rubio Pavilion and the Great Incline is up the mountain out of view on the left.

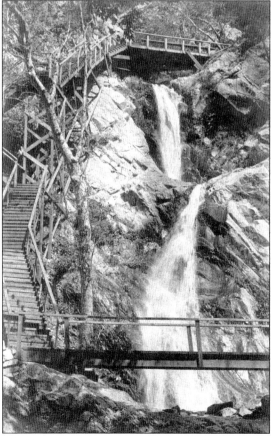

Rubio Canyon featured an amazing wooden walkway that reached deep into the canyon and climbed up its solid granite walls with a latticework of steep stairways. At night, the canyon was lit by Japanese lanterns, creating a fairy-tale-like setting, while the canyon river flowed below the wooden planks.

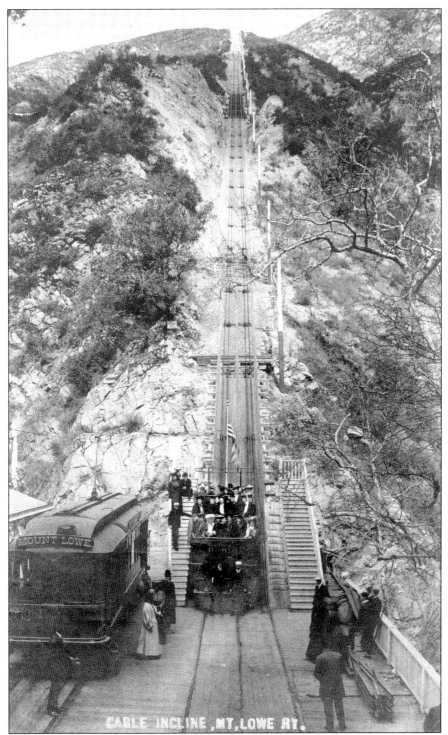

The Great Incline began at the transfer point at Rubio station; tourist would leave their electric trolley car and climb into the "white chariot" taking them up this steep incline to the top of Echo Mountain.

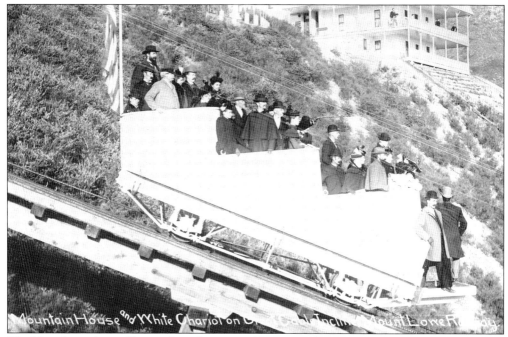

Thaddeus Lowe himself is guiding this tour of his magnificent "railway to the clouds." He is pointing his cane at something of interest in the valley below.

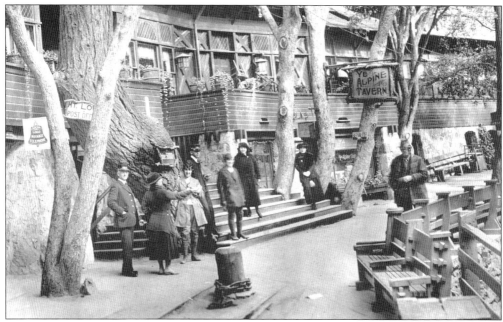

The terminus of the Mount Lowe Railroad was the Ye Alpine Tavern (later named Mount Lowe Tavern). There were many activities for the guests of the rustic tavern, including tennis, hiking, and horseback riding. At Mount Lowe's Inspiration Point nearby, there was a hollow-tube scope with a metal sign hanging below it that read "ostrich farm" and pointed tourists to its location in South Pasadena.

Very few people know today that the original Busch Gardens was located in the Arroyo Seco in Pasadena less than a mile from the Cawston Ostrich Farm. The cover of this brochure depicts the Old Mill, which still exists today, converted from a 100-year-old tourist attraction to a home.

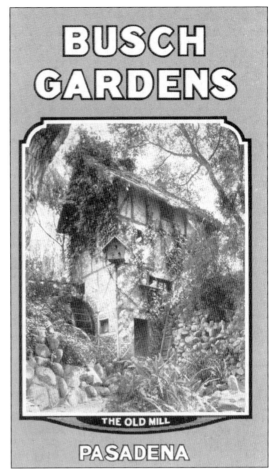

The world-famous sunken gardens of the Busch estate were a marvel of landscape engineering. Adolphus and Lillie Busch purchased much of the Arroyo Seco behind their mansion on Orange Grove Avenue for the purpose of transforming its rugged appearance into a world-class, parklike setting.

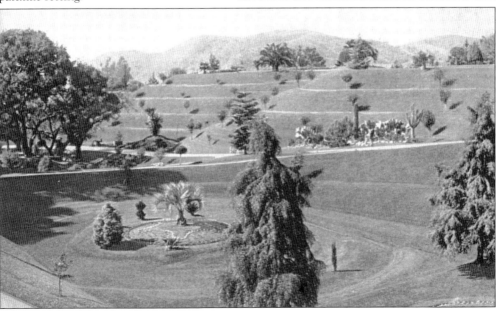

Busch Gardens had over 14 miles of walkways winding through the gardens—twisting, turning, and offering a new picture view at every turn. The gardens had rustic bridges that crossed tiny streams and fairy tales in statuary were seen at a variety of scenic locations.

Visitors of Busch Gardens pose in front of the Mystic Hut, which still exists today on a down slope in the backyard of home.

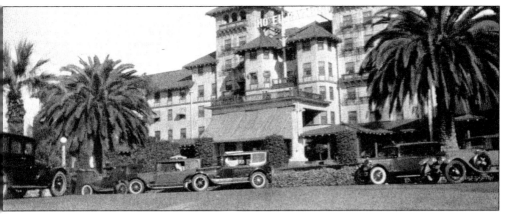
The Raymond hotel was rebuilt and reopened to the public in 1901, enjoying 30 more successful seasons as a major world-class resort in South Pasadena.

This cross-promotion brochure of the Cawston Ostrich Farm depicts the Raymond hotel on its cover.

The short-lived Japanese Village and Deer Park was located in Buena Park, California, near the Interstate 5 freeway. In the early 1970s, the park featured a peaceful Japanese-garden atmosphere, including attractions such as feeding deer, pearl divers, and a karate/samurai demonstration, which interested many kids because of the popular television series *Kung Fu*.

Another Southern California amusement park was the Lion Country Safari in Irvine. The author still remembers the radio and television commercials: a place where "wild animals roar free around your motor car." It was a constant struggle for survival for these entertainment businesses, often requiring huge investments of money by the corporations that own them today. There is no doubt that many of the early wild animal parks were the forerunners of the Disneyland and Knott's Berry Farm of today.

Eight

CAWSTON'S TODAY
HIS LEGACY LIVES ON

Today an industrial park and housing developments occupy the pizza-shaped property (commonly known as the Cawston Tract) bordered by Pasadena Avenue and the Metro Gold Line tracks, which was formerly the route of the famed Santa Fe Super Chief and earlier transcontinental trains. The Cawston Ostrich Farm is generally recognized as one of South Pasadena's two most prominent early business institutions, with the Royal Raymond hotel being the other.

The photograph above shows a vacant lot on the Cawston Ostrich Farm site in 2007. In 1896, the photograph below was taken of Edwin Cawston standing with his wife in the same location from a slightly different camera angle. In 1911, Cawston agreed to sell his ostrich farming empire to a syndicate of Los Angeles bankers for the huge sum of $1.25 million. The ostrich king then returned to his hometown of Cobham, England, where he died nine years later. The ostrich farm, which continued to use the Cawston name, remained in operation even during the waning years of ostrich-feather fashion after World War I. In 1934, the ostrich farm was sold at auction to satisfy a tax claim of $432. One year later, the remaining ostriches were relocated, and the South Pasadena ostrich farm unceremoniously closed its doors to the public forever.

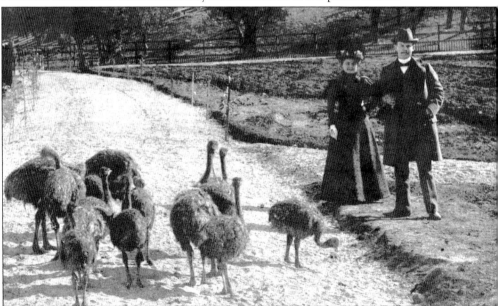

On the site of the Cawston historical marker is a loft housing development named the Ostrich Farm. This statute was commissioned by the developers to honor the history of the farm. Incidentally there are no structures that exist on the historic site that date back to the Cawston Ostrich Farm days. A few years back, the author uncovered a small stone wall that measured about 3 feet high and 12 feet in length that once bordered an ostrich pen next to the railroad tracks. However, it was destroyed during the construction of the Gold Line light rail through South Pasadena.

Mount Lowe can be seen sandwiched between two eucalyptus trees from the Cawston Ostrich Farm site adjacent to South Pasadena's Nature Park.

This was South Pasadena's first bank, built in 1904. Edwin Cawston was the bank's vice-president and made the first deposit of proceeds from his ostrich farm here. The original bank vault can still be seen behind the counter in Kaldi's Coffee and Tea shop.

A city street which borders the Arroyo Vista Elementary School was renamed Cawston Street in Edwin Cawston's honor. South Pasadena hosted an Ostrich Festival during the city's centennial celebration to commemorate Cawston's contribution to the region's early economic development. The Meridian Iron Works (South Pasadena's historical museum) has a display of ostrich farm souvenirs, photographs, and artifacts. The museum is open during the Farmers Market on Thursday evenings and on Saturday afternoons from 1:00 to 4:00 p.m.

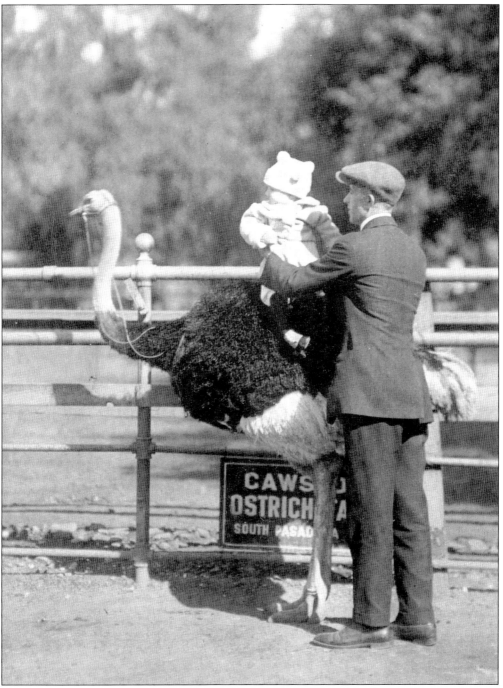

Edwin Cawston's legacy is simple and true, and it speaks to people today. In a very real sense, his legacy is merely a reflection of our own because, one day in the future, you may look back on your life's work and say: I took a big risk, but I pursued my passion and gave it everything I had. On that note, my friend, I wish you well. I hope this book kept you in good spirits, and if you are ever short on hens' eggs in the kitchen, grab an ostrich egg. You can make a couple omelets with that!

Across America, People are Discovering Something Wonderful. *Their Heritage.*

Arcadia Publishing is the leading local history publisher in the United States. With more than 3,000 titles in print and hundreds of new titles released every year, Arcadia has extensive specialized experience chronicling the history of communities and celebrating America's hidden stories, bringing to life the people, places, and events from the past. To discover the history of other communities across the nation, please visit:

www.arcadiapublishing.com

Customized search tools allow you to find regional history books about the town where you grew up, the cities where your friends and family live, the town where your parents met, or even that retirement spot you've been dreaming about.